THE INSURANCE MAN
KAFKA IN THE PENAL COLONY

LINEBOOKS AND THE SIMON FRASER UNIVERSITY GALLERY

2010

THE INSURANCE MAN
KAFKA IN THE PENAL COLONY

EDITED BY

JERRY ZASLOVE & BILL JEFFRIES

Note to the reader.
This publication is a report on the exhibition
The Insurance Man: Kafka in The Penal Colony
installed at the Simon Fraser University Gallery
from April 25 to June 27, 2009.

Library and Archives Canada Cataloguing in Publication

The insurance man : Kafka in the penal colony / edited by Bill Jeffries
and Jerry Zaslove.

Co-published by: Simon Fraser University Gallery.
Includes bibliographical references.
ISBN 978-0-9813906-1-1

1. Kafka, Franz, 1883-1924--Exhibitions. 2. Installations (Art)--British
Columbia--Burnaby--Exhibitions. I. Jeffries, Bill, 1945- II. Zaslove,
Jerry, 1934- III. Simon Fraser University Gallery

PT2621.A26Z4585 2010 833'.912 C2010-906040-7

Canada Council **Conseil des Arts**
for the Arts **du Canada**

SIMON FRASER UNIVERSITY
THINKING OF THE WORLD

BRITISH
COLUMBIA
ARTS COUNCIL
Supported by the Province of British Columbia

This book was previously published as *West Coast Line* 66 vol44 no 2, Summer 2010

Mixed Sources
Product group from well-managed forests,
controlled sources and recycled wood or fiber
www.fsc.org Cert no. SW-COC-003438
©1996 Forest Stewardship Council
FSC

CONTENTS

AN INTRODUCTION TO THE INSTALLATION

» BILL JEFFRIES

Catching sight of a wealthy man driving past in a rich carriage drawn by beautiful horses…as if coming out of a deep trance, he would sometimes comment: "Why he used to be a simple office clerk…"[1]

1 A description of Chichikov in Gogol's *Dead Souls*, New York, New American Library, translated by A.R. McAndrew, 1961 (1842), 256-257; "he used to be a simple office clerk" mirroring Kafka's reception, and his life after death.

» HABSBURGIAN BEST PRACTICES: THE DREAM OF RISK MANAGEMENT

This book is published on the occasion of the exhibition The Insurance Man: Kafka in the Penal Colony, held at the Simon Fraser University Gallery from April 25 to June 27, 2009. The idea for the exhibition at SFU arose when I mentioned to Jerry Zaslove that I wanted to do a Kafka show, and he replied that he had been gathering material toward such a show for some years. What I wanted to do was not at all clear, but would surely have examined bureaucracy, with some emphasis on universities as quasi-Kafkan institutions. Zaslove's project focused on "In the Penal Colony" specifically, and that is what we did; the idea for this specific show was his, as were almost all the materials in it.[2] As it turned out we examined both bureaucracy and penal colonies, along with a wide range of other associated material, including exclusionary/containment phenomena such as concentration camps. Prior to seeing the exhibition, many people wanted to know "What is the show?", to which I could only reply that they should come see it, and that we would try address the question with the publication of this book. In an effort to round out the explanatory apparatus, we decided to invite short texts by authors who did see the show in person; their short essays follow Jerry Zaslove's description of the exhibition and its meaning.

The show's form, which largely avoided the archival-document approach to Kafka, has many sources, but for me it took its cue from a late 1980s' Berlin exhibition titled *Pack Ice and Pressed Glass*, a mysterious, dense, Wagner-filled installation examining the mood, obsessions and ephemeral content of the period from post-Biedermeier Europe (c. 1850) to pre-Weimar Germany.[3] Our Kafka installation utilized archival material, but in aid of a construction that created 'an installation', and by so naming it, the reference to theatricality is already made. In an effort to set the stage, the 'mood' for the piece was created via yellow lighting filters that turned the gallery into a mock-tropical island as an homage to all the island-based penal colonies of the late 19th century. In insurance, the use of what is now termed 'best practices' is part of the larger issue of 'risk management'. The activities Kafka describes on the penal

2 We extend special thanks to Vancouver-based theatre designer Dave Roberts for his ideas and assistance in planning the design of the exhibition.

3 The book of that exhibition, *Packeis und Pressglas*, Anabas-Verlag, Geissen, Germany, 1987, was published on the occasion of the exhibition at Martin-Gropius-Bau, Berlin in 1988, as part of a series of shows created by the Deutschen-Werkbund-Archiv. Published prior to the show, the book, sadly, has no installation photographs; that shortcoming was one impetus behind the extensive use of installation images in this book. ·

colony island may be seen in many different lights, 'best practices' and 'risk management' being only two of them. Kafka was involved in the attempt to improve the world for workers through his job at the recently-invented workers compensation insurance scheme in Bohemia, which was itself an early example of institutional 'best practices' aimed at helping, rather than conquering people. Now, as then, the goal of perfecting things remains both a goal and a dream.

In theory, our installation had many of the same options and challenges as the films made after Kafka's life and stories: we could either follow Kafka as closely as possible, or explore one or more of a plethora of 'creative' possibilities. Because we worked from an idea that Jerry Zaslove had developed over many years, the 'exploration', though certainly present, was kept in line by sticking to the facts surrounding the story. The exhibition exploited the latent stage-set, or movie-set potential in the penal colony setting laid out by Kafka, allowing a *mise en scène* that simultaneously focused on the story, while scenes from *In The Penal Colony* were acted by players in the gallery space—viewers would find themselves, for instance, standing over the beds, more or less as it is in the story.[4] There were no live 'players' in our installation, but the viewers of the exhibition were, in effect, milling about, in character, on a Kafkan stage set.

The implausibility of the penal colony tale might cause one to wonder if many of Kafka's texts derived from his dreams, about which he repeatedly wrote to his friend Max Brod. While impossible to know with any certainty, the curious logic of dreams seemingly has much in common with Kafka's conception of what literature might do in his era; musings about Sisyphean entrapments, being an animal, or the impossibility of real progress are both dream material and Kafka material.

As Alan Bennett has reminded us, it is not easy to get 'doing things with Kafka' right. Conversely, Kafka, an early adopter of the idea of 'best practices' through his day job, seemingly knew how to get it right every time, even if he didn't think so. He was mysteriously able to succeed, for reasons that remain difficult to describe, in getting his readers into his semi-dream-like world via his reportage-like narrative. For those few readers who see no metaphorical content, the tales are, perhaps, simply reports on the state of the world, almost like 'news'. An installation on a Kafka story then becomes, I feel, a reflexive report on Kafka's story, almost like an unsent dispatch or 'news' on a one-hundred year-old story.

It seems important to mention dreams here simply because so many

4 A Kafka film festival was held during the show with screenings at the VanCity Theatre. Features screened included those by Welles, Haneke and Soderbergh; June 22 to 25, 2009.

of them resemble Kafkan situations, or installations. Many people have written about the role of dreams in Kafka. It would be good to know (we never will) if Kafka could have converted any dream into a story told in his voice. If he had a dream about finding a lost object, losing a girlfriend, escaping from a bad situation, obtaining some documents, returning something that he borrowed, or an attempt to return a flawed purchase to his father's store, would we have Kafkan tales on those subjects? I know: we do have those stories. More importantly, I have to wonder if Kafka dreamt about penal colonies after reading Robert Heindl's book[5] in 1912 or 1913? My dream is that the Colony metaphor has to do with the difficulties in running any civic entity—specifically 'the state'—properly; with criminality being one of many risks to the state and penal colonies being one of many attempts at risk management.

5 Heindl, Robert, *Journey to the Penal Colonies*, published as *Meine Reise nach den Strafcolonien*, Berlin, 1912/1913. The book, and references to Kafka's knowledge of it, are one part of Zaslove's installation conception.

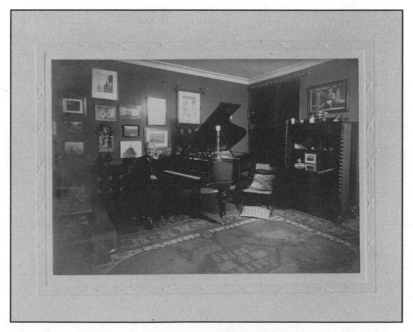

Parlour, Photographer unknown. Prague. Collection of Jerry Zaslove.

Homage # 5 to Franz Kafka, Franz Kafka's Father, Grotto Wall, Waldenstein Castle, Prague,
from the series *Homage to Franz Kafka* by Jerry Zaslove

Prague Hunger Wall, Filipe van den Bosche panorama of Prague, including sections
of the Hunger Wall, 1606. The Hunger Wall was constructed between 1360-1363 by
Charles IV as a works project for the hungry, poor, and unemployed. The Hunger Wall
functioned as a defensive rampart, as well as a boundary. Reproduction in Vaclav Cilek
collection, Prague. Used with permission.

Installation is an art form that has evolved from its operatic stage origins and from Kurt Schwitters' Merzbau 'rooms' (both dream-like) via a circuitous route that paused in Claes Oldenburg's storefront 'sculpture emporium' and in many art school graduation shows along the way. The Russian-American conceptual artist Ilya Kabakov, as much as anyone, deserves the credit for elevating the form to its current status and museum-world ubiquity; we rest on his shoulders, lightly. We have no way to know if the penal colony story came from a dream, but, regardless, in our exhibition it evolved into an 'installation as dream', mainly because of the strangeness of seeing so much Kafka text material on the walls bathed in yellow light. We described this exhibition as a metaphorical construction building on Kafka's penal colony story—fully realizing that every gallery/museum installation is also a construction. Kafka's genius in the story is not to see it as a dream, but to see penal colonies as a type of theatricality, as a set into which the subjugated play out their parts, their roles, and in which a range of modernist aspirations are, for all their good intentions, sent up as laughable failures. Kafka was as familiar as anyone with the notion of good intentions—it began with his parents' wishes for his future and was subsequently the core of his insurance work. The contradictions contained within packages of good intentions could not have been lost on him, nor could the actual human suffering in the story which was not at all 'theatrical' to any sensitive observer.[6]

Installation art, as it is with other media, is normally about an artist's idea, and our show was that, but one step removed; it was about Jerry Zaslove's idea of what Kafka's idea was about. (again, see JZ's essay following for elaboration on this.) The show was constructed, according to Zaslove, as an entry mechanism for *In the Penal Colony*. I'd suggest that we provided a doorway, one that would have been useful for the character in Kafka's story "Before the Law", who so much needed a door to be opened for him. Installations are translations of ideas external to what is installed. Artists translate from concepts into form; what we/Zaslove did was translate from Kafka's concepts into forms that are both directly and tangentially related to the architecture and processes of Kafka's story.

An exhibition such as this makes it easier to think of Prague itself as an installation; perhaps then and certainly now. Prague's position circa 1900 mirrored that of individuals in many countries; things were improving in some areas of life for citizens, cities and empires, in part

6 In Vancouver we have scenes of human degradation on the infamous Downtown Eastside; these scenes have been sought out by many, some of whom were visitors from Europe, as a type of theatrical performance or street theatre that was 'worth a detour'.

as a result of attempts to implement enlightenment/modernist policies. If Modernism is a sibling of the Enlightenment, Kafka's penal colony is a hyperbolic, but logical extension of where it all might lead. In Europe, the period from 1850 to 1910 constituted sixty years of a Modernizing process that was inescapable. Prague did not escape; but even the Hauss-mannization of the Jewish Ghetto in Prague, lamentable though it may have been, resulted in streetscapes that would be the pride of any city today. Prague was not smart enough to know how to build ugly buildings; it had architectural negative capability. The aspect of sociological Mod-ernism that is often illustrated by the changes one experiences in one's surroundings from week to week, were part of Kafka's reality, but, as with Modernism's respect for the good work of the ancients, Prague was also a city that retained much of its past physical form, with swaths of the city being either old or ancient. Every form of Modernism has either existed in that duality of the new within the old or incorporated it—Prague was a bit like *The Waste Land*—it incorporated new into old in a mélange. A glass office tower in an old city creates two solitudes—a duality of two separate, irreconcilable differences, existing in a state of conflict, each challenging the other. *In The Penal Colony* (and much of the rest of Kafka) is a glass tower in the old city of literature.[7] Kafka's multi-cultural Prague may, for all we know, have been an exemplar of the well-run city-state, comparatively speaking, the 'state' of its plumbing notwithstanding.

The coming war was in the air at the time the penal colony story was written and the running of almost all European states became a war man-agement project; war, the ultimate form of human stupidity, became the dominant reality and by its unfolding it was proof, if proof were needed, that it is very difficult to run a state in any kind of proper or ideal way, even at the best of times. 1914 was not the best of times, war was a rumour and then a reality. In war, success is always failure for someone. Kafka's repeated use of the word 'torment' in his letters presaged the torment of the war itself.

Through his work Kafka must have known that things, in order to become modern, had to run like machines—this was already conventional wisdom in manufacturing (hence Kafka's job), architecture, farming, the provision of electricity, and in politics, thanks to Machiavelli. Kafka's penal machinery doesn't just have flaws; it is flawed in every possible way, from its purpose, its conception, its functioning and its treatment of 'citizens'. Like the state, it is having a difficult time living up to its 'ideals'. Kafka

7 In an earlier version of this text in which I described the contents of the room in more detail, I mentioned that there was blow-up of 16th-century Prague panorama, showing the city as it was: even then, dense, complex, an urban maze-like island that signified "it is from this density that Kafka emerged."

scholarship may frown upon metaphorical readings of his stories, and comparisons with Kafka's compromised relation to other entities (family, girlfriends) could easily allow a reading in which the torture machine stands in for those entities. It is the functioning and mis-functioning of the state that has the broadest impact, however, far overshadowing the discomfort and mental torment that a difficult relationship or a bout of writer's block might have. If we are doomed to live within imperfectly functioning states then commentary may be the only viable mode of revenge, at least as Kafka saw it, and comedy the highest form of commentary, because if we believe Kafka, there is almost no situation that does not have its comical side.

Sv. Štepán [Saint Stephan] Vaclav Cilek Photographs

"In a Viennese café a man orders coffee without cream. We're out of cream, the waiter says; would it to be all right to have a coffee without milk?"[8]

Max Brod tells us that when Kafka read his stories aloud to his friends they would fall over laughing and that Kafka would then himself laugh so hard that he couldn't continue. I have a theory that the humour in Kafka is perhaps not so accessible to solitary readers—the humour is not so obvious when there are just two of us—just a Kafka story and ourselves. A solitary reader of Kafka laughing would seem odd; they'd be not unlike a hands-free phone user talking while walking down the street—men in white coats might be following. The multi-valency of the stories, their ability to be about many things simultaneously, makes their primary subject difficult to pin down, although each individual reader may well feel that they do themselves 'get' the primary reading. The interpretation of every Kafka tale is contested territory, but anyone who has read even a few of the tales has a theory, one that they may assume has the authority of being 'right'. The degree to which humour is a key element in Kafka is part of the contest. Once readers are told that interpretations of a story's meaning might cast it in a humourous light, then we can see that there is another, somewhat hilarious context into which Kafka's works may be reconsidered. If my interpretation of Kafka has him exploring the fraught relations between the individual and the state in much of his work, as did his working life as a lawyer at the Workman's Accident Insurance Bureau, where he was triangulated by people, government and business, then there is the question of whether states, like the machine in *In The Penal Colony*, are designed and structured to 'run themselves'. If running a state is not an easy thing to do, especially because they suffer by comparisons with their templates, perhaps laughter becomes the only appropriate response to governmental follies.

Levity is the great solution to despair and irony is levity's great friend. Kundera's idea that the "craft of the novel is that of irony"[9] leads him to Kafka's relation to a Jewish proverb: Man thinks, God laughs.[10] Kafka's un-Wildean mirth is more like black humour, whether God-like or not, and its often-cited source is in his relation to, and admiration for, Yid-

8 Herzog, Werner, *Conquest of the Useless*, (his Fitzcarraldo diary) translated by Krishna Winston, New York, 2009 (2004 as *Der Eroberung des Nutzlosen*), 210

9 Sternstein, Malynne, "Laughter, Gesture, and Flesh: Kafka's 'In the Penal Colony'", in *Modernism/Modernity* 8.2 (2001), 315-323

10 Kundera, Milan, "Jerusalem Address," in *The Art of the Novel*, translated by Linda Asher, New York. Grove Press, 1988), 158, cited in Sternstein.

Frydlant Castle, Scraffito Wall, photograph by Vaclav Cilek. Castle Frýdlant v Čechách is located in Frydlach(Friedland in German) in North Bohemia and was owned by Count Christian Clam-Gallas at the time of Kafka's visits to the town to examine the Textile Factory Siegmund, which was located not far from the castle. Some Kafka scholars believe that this is the source of the location for Kafka's novel The Castle, because of the name of the owner of the castle (Clam-Gallas). "Klamm", is the mysterious figure in the novel whose name and spirit hover over the town.

dish theatre. This link has been explored in many of the recent books on his work but the binary-isms in Yiddish theatre should lead us to think about Kafka in Levi-Straussian, structuralist terms. It was Levi-Strauss who uncovered the previously mysterious connection between the layering and placement of things in the world, their orientation. It was Yiddish theater, however, that mined the 'layering of society' as much as any prior art form, exploring what I now think of as the 'Kafkan sandwich' (i.e. layers) that we can now see as normal because of Kafka's descriptions of how we are squeezed between 'this and that'.

In the installation, various layers of Prague society were represented by photographs and paintings of citizens from a wide range of Prague society circa 1910–1920. Each picture depicted the individual's microcosm of the Prague version of the human condition. For me, each portrait, ranging as they do from confident empowerment to sadness bordering on despair, perfectly achieved what portraiture can do when at its best: completely

personal and about the individual and simultaneously universal. It was one of the strokes of curatorial genius that Zaslove realized how important it was to find a way to involve the people, the citizens, who were the broader context, if not audience, for Kafka's literature. The ability of any artist or author to deal with metaphysical issues is always linked to their willingness to take the risks associated with representing the human condition. Yiddish theatre, with its music, song and dance, shares elements with both opera and 'the musical', but differs in that it is grounded in metaphysical dilemmas. It is those dilemmas that Kafka shifted into his stories, but their source in theatre seemingly allowed him to see much more humour in his tales than his readers did, initially anyway. Kafka interpretation can refer to his humour, but it cannot 'become humourous' without undermining its own intentions—hence this installation avoided it. The photographs of Prague's citizens show us the challenge Kafka faced—there is little doubt that each person pictured knew how to laugh, but it is hard to imagine them laughing.

The thinly veiled levity might have been more readily accessed if Kafka's fellow citizens could have read *Catch-22* before reading the man himself, a sequential impossibility, but it might have paved the way to an opening up of the reading of Kafka. The comic aspects that emerge out of Kafka's versions of modernity—his treatment of modernistic attempts to construct a perfect mechanism that can be described in the best possible, excessively logical terms, whether the state, the judicial system, the prison system, the family, the workplace —they all have their 'challenges'. If the family is a microcosm of the state, poor Kafka had at hand an acid-etched example of how difficult it is to run a 'state' of six people so that they would have a chance to derive any pleasure from life. Indeed, for many, it would be easier to run a state with six unrelated people, something on the scale of a penal colony, for instance. The various attempts to transfer scientific principles to the social sciences, which have ranged from personal psychology to international relations, have all run into the forms of resistance and difficulty of application that Kafka continued to probe throughout his life. This installation, and Jerry Zaslove's text that follows, as well as the shorter essays following it, are our part in the probing of one of Kafka's probes, as is the installation itself.

Installation view: Museum Vitrine with Svejk Puppet. Collection of Jerry Zaslove. Vitrines contain Kafka's favorite literary ephemera or objects related to his cultural ethos, for example Alfred Kubin, photograph of mining, letter from his Dr. and children's books. Photograph courtesy of SFU LIDC.

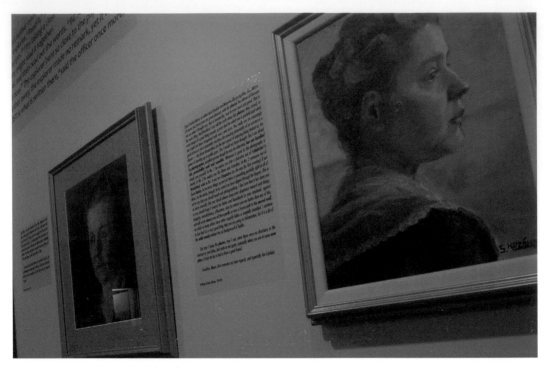

Installation views: with by Bozena Kozakova, 1913. Models supplied by the Czech School of Fine Arts, which stood adjacent to Kafka's home and his father's shop. Collection of Jerry Zaslove.

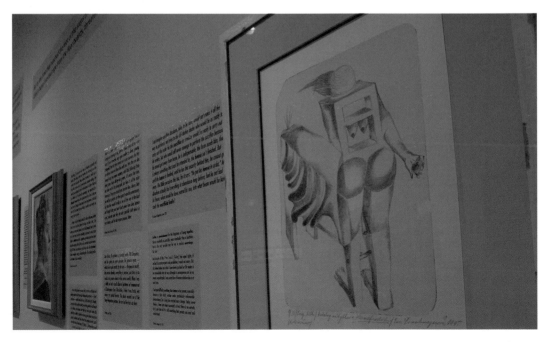

Installation view of Eva Svankmajer (Surrealist artist and animator) Hermaphrodite n.d. Pencil and crayon. Collection of Jerry Zaslove.

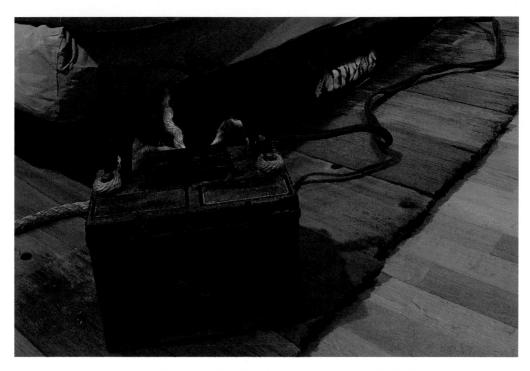

Installation view: Battery and Cable Connected to Officer. Photograph courtesy of SFU LIDC.

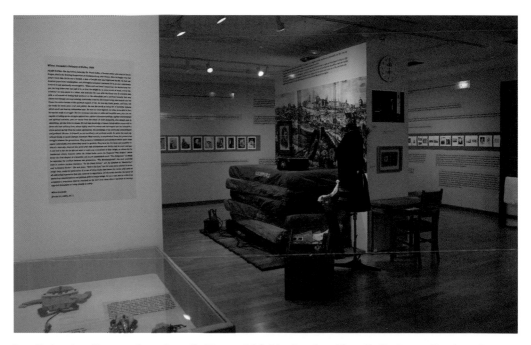

Installation view: Photographs on far wall of Prague Celebrities, Langham Photo Studio, Bozena Kozakova, Prague School of Arts. Right wall, Kafka's anti-militarist texts, and anti-war illustrations from Ernst Friedrich's War Against War, 1924 The Torment Machine with Prague Panorama, Battery, Officer and Beds of 'Machinery', 'Sleeping', 'Marriage', 'Office', 'Hospital', 'Writing,' Watched over by "Explorer". Charcoal and crayon. Photograph courtesy of SFU LIDC.

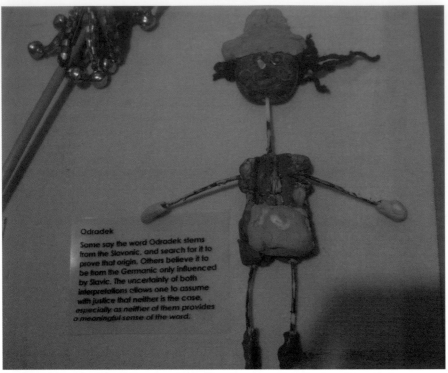

Within the image, the exhibit label reads:

Odradek

Some say the word Odradek stems from the Slavonic, and search for it to prove that origin. Others believe it to be from the Germanic only influenced by Slavic. The uncertainty of both interpretations allows one to assume with justice that neither is the case, especially as neither of them provides a meaningful sense of the word.

Installation view: Odradek Doll. Creation of Tara Silva, five years old. Collection of Jerry Zaslove. Photograph, Christine Liotta.

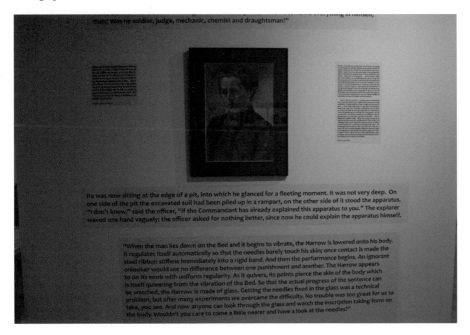

Installation view: Double Sided Kafka, Sandwiched Glass Newspaper Clipping with 'Unknown Letter of Franz Kafka Found'. Montage construction Jerry Zaslove.

Installation view. *Death bed with palm tree.* Photograph courtesy of SFU LIDC.

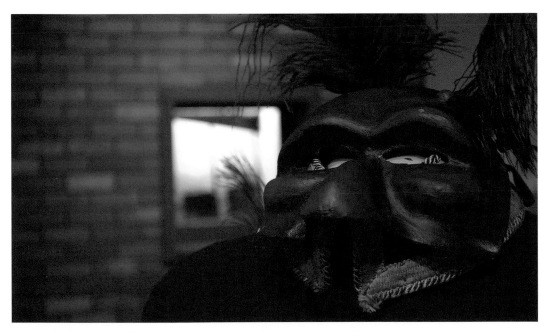

Installation view: *Comedia Masks on mannequins.* Reproductions of masks from 18th century baroque theatre in Cesky Krumlov, Czech Republic. Photograph courtesy of SFU LIDC.

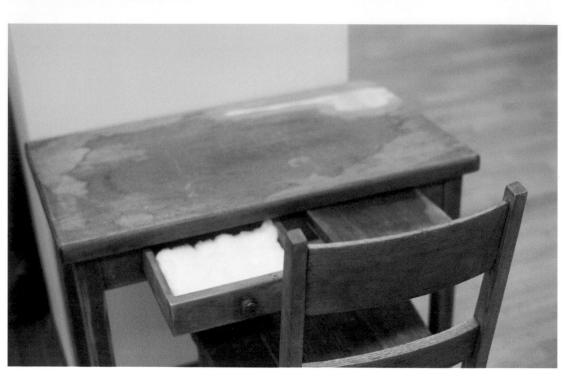

Installation view of desk and chair with cotton batten in drawer as simulacra of Terezin Concentration Camp office. Photograph courtesy of SFU LIDC.

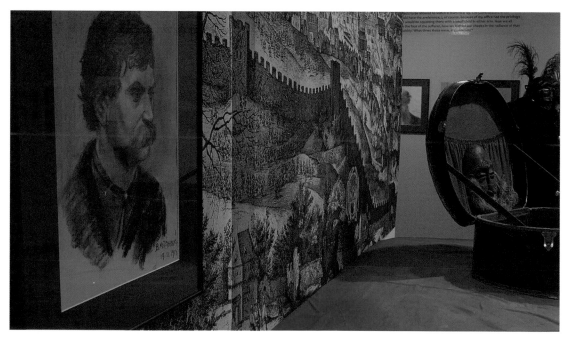

Installation view of Bozena Kozakova portrait representing the Explorer observing the beds with panorama of Prague. Photograph courtesy of SFU LIDC.

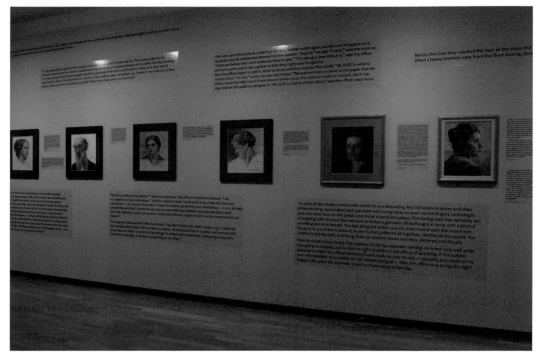

Installation views: portraits by Bozena Kozakova, 1913. Models supplied by the Czech School of Fine Arts, which stood adjacent to Kafka's home and his father's shop. Collection of Jerry Zaslove. Photograph courtesy of SFU LIDC..

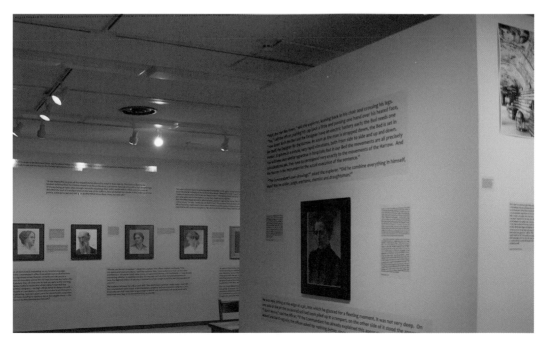

Installation views: portraits by Bozena Kozakova, 1913. Models supplied by the Czech School of Fine Arts, which stood adjacent to Kafka's home and his father's shop. Collection of Jerry Zaslove. Photograph courtesy of SFU LIDC..

Installation view Comedia Masks on mannequins. Reproductions of masks from 18th century baroque theatre in Cesky Krumlov, Czech Republic. Photograph courtesy of SFU LIDC.

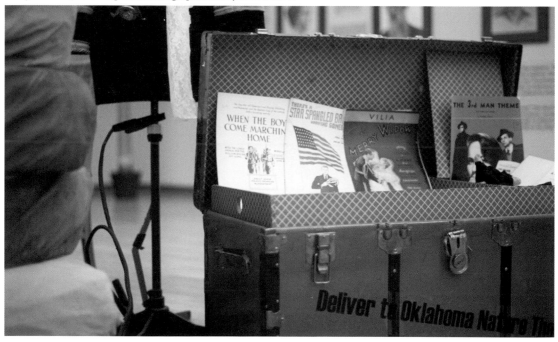

Installation view travel Trunk "Amerika—The Nature Theatre of Oklahoma". Trunk contains Charlie Chaplin Hand Puppet. Photograph courtesy of SFU LIDC.

THE OFFICER SHOWS THE LABYRINTHEAN BLUEPRINT FOR THE HARROW MACHINE TO THE EXPLORER WHO CAN BARELY READ THE NOTES

- *Lots of flourishes around the actual script are needed*
- *The script runs around the body in a narrow girdle*
- *The rest of the body should be saved for ornamental marks*
- *Run up the ladder to turn the wheel if necessary*
- *Call to those below to beware the noise*
- *Watch out when coming down*
- *Look up at the Apparatus to check it out*
- *Follow the script if you can*
- *If it is not in working order climb back down into the pit and fix it*
- *Note that the Harrow writes the inscription on the back of the prisoner*
- *Slowly turn the prisoner over to allow for more free space for writing*
- *Deepen the raw wound that has been inscribed and staunch with cotton wool*
- *The teeth of the Harrow now tears the cotton wools from the wounds*
- *Pitch the wool into the pit so the Harrow can do its deeper work*
- *The writing work will take twelve hours*
- *Note that for the first six hours the condemned man lives merely as he did before*
- *Note: He suffers only pain*
- *After two hours the felt packing is removed*
- *Note: the man no longer has strength to scream*
- *Warm milk-rice from the electrically heated basin is set at the head of the bed*
- *The man can use his tongue to lap up as much as he wants*
- *Experience shows that few miss the chance to eat*
- *At about the sixth hour the man loses any desire to eat*
- *I usually kneel down to observe this phenomenon*
- *The man rarely swallows the last bite and rolls it around his mouth before spitting it into the pit*
- *Be sure to duck or it will come into your face*
- *The man will grow quiet in the sixth hour*
- *Expect Enlightenment to come to even the stupidest fool*
- *It begins around the eyes and spreads beyond him into a moment that could tempt oneself to get under the Harrow with him*
- *Nothing further happens except the man begins to decipher the writing and purses his lips as if listening*
- *One will see it is not easy to decipher the script with one's eyes but our man deciphers it with his wounds.*
- *Be aware it's hard work and it takes all of six hours until completion*
- *Then, the Harrow pierces him through and through and throws him into the bottom of the pit where he pitches onto the blood and water soaked in the cotton wool.*
- *Then the judgment is fulfilled and we, the soldier and I, bury him like a dead animal.*

MY JOURNEY TO THE PENAL COLONY

(AFTER THE STORY BY FRANZ KAFKA)

» JERRY ZASLOVE

There are also projections that cannot be explained, because the artist sometimes shows a faculty for projecting inner images in such a way that they become almost real or entirely so. You have to take care not to write the law simply and unimaginatively by itself but to put yourself in motion around the law.
 Paul Klee, Diaries, 1918 – 1922.

The fact that the only world is a constructed world takes away hope and gives us certainty.
 Franz Kafka, Zürau Aphorisms

The installation "The Insurance Man: Kafka in The Penal Colony" is about a subject common to Kafka: authorship. The installation is not only about Kafka the literary figure, but also Kafka the artist and the zones of affinity within his inner life to materials of the everyday, the commonplace. "Kafka's Room" becomes the installation. I become the imaginary narrator of the story. The viewer becomes both the author and the narrator. The narrator is inside the constructed room while the author is at once inside and outside. Similarly Franz Kafka the author of "In the Penal Colony" is both inside and outside the story. In the room and not in the room. This is not a programmatic installation that simply illustrates the text, rather it is about the text: the story and its genealogy. I take up a challenge to myself: to make a representation related to the Kafka myth that has followed us since its reception after World War II. The installation is an attempt to project how Kafka thinks with and through the objects around him. In this essay I write about my fascination with the story and what has influenced me in the making of this installation. This is the beginning of a study of the genealogy of the story and at the same time a way of presenting the story through colportage and archival collecting.

Colportage is an assemblage of remnants of the material world. In Kafka that necessarily passed world produces in us the feeling of the uncanny and the phantasmagoria because the scenes he constructs in his work function almost as still photographs derived from a cinematic presentation of the commonplace. This is not the grotesque but a genealogy of how the roots of the present stay alive in the traces and remnants of worlds that shadow the scenes. The past has not yet completely vanished. Put another way, the installation is an attempt to portray how Kafka forces the future upon us by showing the ruins of the past in the present. We feel the very last things from the past. This use of the past became an aesthetic problem for modernist artists struggling with the future that is projected to us from the past. Malevich, for example, traced the confluence of primitivism and constructivism by asking: "How can epoch making events be

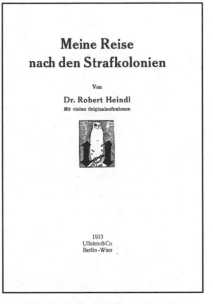

Meine Reise nach den Strafkolonien [My Journey to the Penal Colonies] Dr. Robert Heindl, 1913. Photographs by Robert Heindl. New Caledonia, Andaman Islands, Ceuta, Sydney

transmitted through art?" He then asked: "How does the past leak through into the future of the art?"

The method of the installation—colportage—exhibits an aesthetic framed by objects that are premonitions of something awful about to happen. Torture for Kafka—the mere thought of torture—tortures him. Colportage is used as a "category of illustrative seeing" in the manner of Walter Benjamin's description of the behaviour of the flaneur as a collector of objects, who "composes his reverie as a text to accompany the images." I wanted the installation to make the viewer into a flaneur in the spirit of Benjamin who describes the flaneur as a "colportagist", one who lives, he writes, in a "phenomenon of space ... everything potentially taking place in this one single room is perceived simultaneously. The space seems to wink at the flaneur: "What do you think may have gone on here?" Of course, it has to be explained how this phenomenon is associated with colportage.[1] I the author/narrator attempt that explanation as it might apply to the installation itself and to a reading of "In the Penal Colony". I become an ethnographer-author who collects materials related to the story, just as, Robert Heindl, the author of Journey to the Penal Colonies, became a flaneur in the prison colonies of the South Seas.

Heindl, a lawyer, traveled, in the service of the German government, to the South Seas to research and report about the incarcerated, the exiled, European and indigenous criminals, who were deported to these exotic islands that were being used as penitentiaries and labour colonies. Prisoners were not only from Europe, but from Asia and the Asian Sub-Continent, sentenced by their own people's courts and the colonial administrators for a range of crimes. Heindl collected statistics about everything, including escapes, mortality, diet, work forces, finances, stories, laws and codes. He also took photographs. He wrote dispassionate, but enthusiastic accounts of what he saw. His discourse is troubled, inquisitive and eager, the scenes entertain him. He has sharp yet complacent eyes. Heindl is the imaginary visitor to the installation. Kafka created his Explorer-researcher in the image of those who have Heindl's studied innocence toward violence and officialdom. Heindl, like the Explorer cuts a figure who is distanced from the brutalities he reports to Europe. His fascination with the progressive enterprise of prisons is infectious, but so are his descriptions of bamboo-branch beatings of prisoners and even guards who fail in their duties. Bourgeois comforts of Sunday walks in the "bush" with families accompanied by prisoners amuse him and persuade him that the ethos of the island is just like Europe.

1 Benjamin, Walter, *The Arcades Project*, translated by Howard Eiland and Kevin McLaughlin, Cambridge, Massachusetts and London, 1999, 418-419.

Heindl collected a massive amount of data about "white and dark criminals, murderers, street crooks, pirates, prison wardens, police, confidence men, hangmen and black trackers" imprisoned by the British, French and Indian police on various islands. He characterizes his adventure as a "gypsy journey" in a discourse that Kafka's story takes seriously, but also subtly mocks. He returns with trunks filled with exotica. He describes these goods as second hand, mere trash, the junk of culture, materials collected from the deported, exiles and expatriates, men and women, who live (in his words) on dead and remote islands. He reports on diseases such as malaria and tuberculosis, nutrition and length of sentence as well as the factories and foremost, the bodies of the worker-prisoners and their families. He describes in stereotypical fashion the "delicate Japanese and robust Papuans", "bow legged Australian Bushmen", young maidens and overseers, all seen

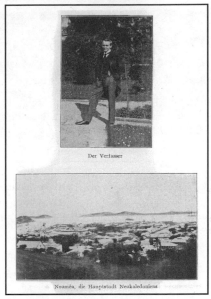

Der Verfasser

Nouméa, die Hauptstadt Neukaledoniens

through the eyes of one who anticipates violence everywhere yet always appears refreshed and in control. His photographs represent a placid, utopian communal ethos, depicting his fantasy of a civil society directly related to the Officer's law-abiding vision of punishment in Kafka's story. At the end of his ethnographic mission Heindl reflects on his journey as "fantastic, a horrible procession ... [of images] which would be worthy of the drawings of a Callot or Rops."[2] He is not a writer of travel books but is an ethnographer—a colporteur—of the fantastic, whose objective truth-telling will show Europeans how progressive their society can be.

However Kafka does not depict the fantastic or the surreal. He feels the surreal. He depicts Heindl's narrative in the manner that Peter Weiss described Kafka by comparing him to Breughel. Weiss describes Kafka's art as building on "the definitive gap in power and privilege that was expressed in Kafka's book [The Castle]". This definitive gap is the basis of the chronotope of transience, assemblage and colportage that lies at the heart of this installation that I hoped would unsettle predictable images of Kafka.[3] A comparable approach might be T. J. Clark's *The Sight*

My Journey to the Penal Colonies, page 17 Above: The Author of My Journey to the Penal Colonies, Robert Heindl, Below: Noumea, The Capital New Caledonia.

2 Heindl, Robert, *Meine Reise nach den Strafkolonien*, Berlin, Wien, Ullstein, 1913

3 Clark T. J., *The Sight of Death, an Experiment in Art Writing*, New Haven and London, Yale University Press, 2006.

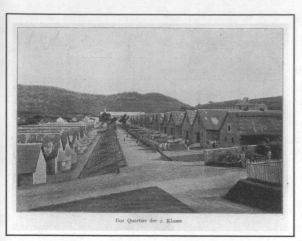

Das Quartier der 2. Klasse

My Journey to the Penal Colonies, Prisoner Quarters, 2nd Class, page 49.

of Death, an Experiment in Art Writing. Also useful is Clark's method of showing how painters think in *The Absolute Bourgeois, Artists and Politics in France,* Clark writes (123) "... that the artist's power to generalize is founded on particular knowledge, on an accuracy which includes the facts, even details of politics."[4] This can also describe Kafka.

By placing Kafka's words from letters, diaries, works and aphorisms on the walls of the room I hoped to create a chronotope—a space-time image—of both the story and the machine in the penal colony. The object of the installation is Kafka, but Kafka is there only in the image of his language. There is no picture of him or explanation of the story. By "chronotope" I mean the room itself is a space-time configuration of a mental space. The installation, then, is a futurist installation, to be understood as extracting elements from a dead object—the machine in the penal colony—and bringing to life the violence in the story through the viewer becoming familiar with the objects and images that Kafka would know were legacies of violence. The machine in the story can be seen as a futurist construction not unlike Malevich's or Vertov's series of objects—angry toward the past, yet compelled to represent it, mechanistic in the present that is redolent of war, violence and revolution—all pointing and driven toward the future. The anonymity of the materials in the installation allows the viewer to become a colporteur who notes the reports, documents, words, and materials that exist side by side with ruins. The colporteur treasures ruins, the antiquated, traces of the past and intimations of the future. I treat Kafka as a colportagist of the commonplace in which violence, materiality and transience live side by side. The viewer becomes Robert Heindl.

Michael Haneke, who created the great film based on Kafka's *The Castle*, puts the problem of depicting violence this way:

> How do I give the spectator the possibility of becoming aware of this loss of reality and their own participation in it in order to emancipate oneself from being the victim of the media by being its possible partner? The question is not: what can I show? But, what chance do I give the spectator

4 Clark T. J., *The Absolute Bourgeois, Artists and Politics in France,* 1848-1851, Princeton, Princeton University Press, 1973.

to recognize the depiction for what it is? The question—talking about the theme of violence—is not how do I show violence? But, how do I show the spectator his own position in regard to violence and the way it is shown.[5]

Haneke's approach is echoed by Peter Weiss in his own films and writings that compares Breughel and Kafka in *Aesthetics of Resistance*:

> *. . . Breughel's paintings . . . in an autumnal Bohemia melted into the Flemish landscapes of the sixteenth century, just as during the next few days when I read Kafka, the hamlet and the castle he depicted belonged to the dismal, petty bourgeois rustic isolation of my surroundings. Breughel and Kafka had painted world landscapes, thin, transparent, yet in earth tones, their images were both shiny and dark, they seemed massive, heavy on the whole, glowing, overly distinct in their minutiae. Their realism was placed in villages and regions that were instantly recognizable yet eluded anything previously seen, everything was typical, demonstrating important central things, only to seem exotic, bizarre at the very same moment.*[6]

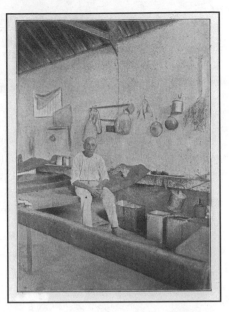

My Journey to the Penal Colonies, Inner View of Prisoner Barracks. New Caledonia. page 49

The baleful beginning of the twentieth century inaugurated forms of violence that were created by Empires already falling apart even while holding onto still-existing Feudal social contracts. Europe itself was becoming a penal colony, as a result of nations being annexed and empires falling into dissolution. WW I, when the story was composed, was not the end of colonization but another passage to future expansions of powerful institutions and the eventual decline of the world that the Explorer-Researcher came from. In 1945, at the end of WW II, Yalta partitioned and rearranged Europe and its peoples. This dismemberment was a continuation of the violence, horror and brutality that Kafka witnessed in WW I. Kafka—in addition to Picasso and others—became a way of seeing the crucial epoch when the means of expression exposed the contradictions

5 Haneke, Michael, *Nahaufnahme, Gespräche mit Thomas Assheuer [Closeup: Conversations with Thomas Assheuer]*, Berlin, Alexander Verlag, 2008,200. (My translation, J.Z.)

6 Weiss, Peter, *The Aesthetics of Resistance*, volume 1, translated by Joachim Neugroschel, Durham and London, Duke University Press, 2005, 149.

of monopoly capitalism. People exposed to a world without shelter were also exposed to the new depictions of the vanishing point of the individual. On the agenda in art, music and literary depictions were the modern artistic manoeuvres of what Walter Benjamin called "raising a paw" against the "the products of decay". In Kafka's 'penal colony' this takes us into the aesthetically unknown, where consciousness exists at the threshold of waking, grief, and the dream of violence remembered.[7] For Benjamin the collector studies and loves the objects because they do not have a utilitarian value, but function as a "scene, the stage, of their fate ... a magic encyclopedia" in discarding exchange value for use value "whose quintessence is the fate of his object."[8] Here comes the writer. Here comes the Explorer-Researcher! Here comes Kafka.

> *I want to write, with a constant trembling on my forehead. I sit in my room in the very headquarters of the uproar of the entire house. I hear all the doors close, because of their noise only the footsteps of those running between them are spared me, I hear even the slamming of the oven door in the kitchen. My father bursts through the doors of my room and passes through in his dragging dressing gown, the ashes are scraped out of the stove in the next room, Valli asks, shouting into the indefinite through the anteroom as though through a Paris street, whether Father's hat has been brushed yet, a hushing that claims to be friendly to me raises the shout of an answering voice.* [9]

The objects Kafka hears are inner as well as external: they mediate the distance between the thin skin of the writer and the interior of the writing. The installation is the prehistory as well as the posthumous memory of objects that are framed by 'the room' in Kafka's head. "Posthumous" because these memories never leave Kafka, they recur again and again; as when the Explorer-Researcher leaves the island, the memory of what happened stays with him—it is *that* traumatic and strange. Memory in Kafka becomes visible, yet is frozen into a strange and alien calligraphy. For instance the Officer whose machine is designed to abolish the memory of violence, even as it inflicts torment tells the Explorer it's a calligraphy: "Yes," said the officer with a laugh, putting the paper away again, "it's

7 Benjamin, Walter, "Max Brod's Book on Kafka," in *Illuminations*, edited by Hannah Arendt, translated by Harry Zohn, New York, Harcourt, Brace & World, 1968, 147.

8 Benjamin, Walter, "Unpacking my Library." in *Illuminations.* edited by Hannah Arendt, translated by Harry Zohn, New York, Harcourt, Brace & World, 1968, 60.

9 Kafka, Franz, *Reflections on Sin, Suffering, Hope, and the True Way, and Other Posthumous Prose Writings*, edited by Max Brod, translated by Ernst Kaiser and Eithene Wilkens, London, Secker and Warburg, 1954, 40. These are also known as the *Zürau Aphorisms*.

no calligraphy for school children." Memory is scattered, but functions in the room much like the "Odradek" figure in Kafka's "The Cares of a Family Man" where the figurative nature of memory comes back again and again, but without a name. Odradek, the figure of "care" that haunts Kafka's work, is an uncanny figure that has not yet become a person. One can say that Odradek illuminates the prehistory of care:

> *Some say the word Odradek stems from the Slavonic, others believe it to be from the Germanic, influenced by the Slavic. The uncertainty of both interpretations allows one to assume with justice that neither is the case, especially as neither of them provides the word with the meaningful sense it deserves.[10]*

The installation of objects attempts to create that ethos of the presence of such an Odradek, who once cared for the family, as our guiding principle. The prehistory of the story can be seen as the prehistory of care. *Sorge* in German means not only care, but concern, and even sorrow. In the exhibition, care is centered on the beds and the panorama of the walled old city that stands behind the beds. The figures peering at the beds are the puzzled but compassionate viewers of the torment. Each object in the installation is a relative in Odradek's care—it's a family room. Kafka wrote to Felice Bauer, his fiancé, at the time of reading his story "In the Penal Colony" in Munich:

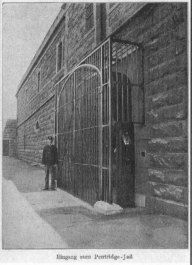

Eingang zum Pentridge-Jail

My Journey to the Penal Colonies, Entrance to Pentridge Jail, New Caledonia, page 193.

> *I had come, borne by my story ["The Penal Colony"] to a city that was no concern of mine except as a meeting place and a deplorable youthful memory, read my filthy story there to complete indifference, no empty stove could have been colder than that hall, then spent some time with people I don't know—which seldom happens to me here.[11]*

A few years later, Kafka described his struggle with memory: "I am a memory come alive, hence my insomnia". The walls of the room in which

10 Kafka, Franz, *Franz Kafka, The Metamorphosis, The Penal Colony and Other Stories*, translated by Willa and Edwin Muir, New York, Schocken Books, 1948, 160. [Translation altered. JZ]

11 Kafka, Franz, *The Diaries of Franz Kafka*, 1914-1923, Edited by Max Brod, translated by Martin Greenberg with the co-operation of Hannah Arendt, New York, Schocken Books, 193.

Kafka in the Penal Colony was installed were littered in a planned manner with excerpts from his memoirs, diaries, writings and letters. It is possible to walk the streets of Prague and go into museums and synagogues and see the names of the murdered inmates of concentration camps on the inside or outside of the walls of buildings, or to walk through cemeteries that Nazi troops had rampaged and plundered, destroying tombs and tombstones. Resistance fighters—often Communists are named—have cemeteries throughout the region and there are cemeteries in Prague and elsewhere for Russian soldiers and even Canadian airmen as martyrs of resistance. The Installation of the Penal Colony is also another kind of memento mori. The listing of the dead on walls that commemorate Jewish and other victims of the Nazi penal colony camps is depicted indirectly by my use of Kafka's writings on the walls of the Gallery. The writing becomes graffiti on monuments. The landscape is littered with vanished memento mori.

It is an assembly of materials related both to Kafka and to my reading of the chronotope of "Kafka". We can also imagine Kafka's continuing presence as an Odradek, who is all around us, a figure hidden in the room. Kafka is in the room and in our lives, yet in the installation his image does not appear. Yet once one enters the room he is never far away. Perhaps that is his secret—to remain invisible yet visible like Odradek who appears many times in the drawers of the vitrines, sometimes as a child's clay model, sometimes in period children's books, often as the character Svejk from Hasek's *The Good Soldier Svejk*, a work parodying WW I and contemporary with Kafka's story. The room is also a place where the memory traces of images from childhood are never far away from Kafka's world. Children have a special place in Kafka's story when the Commandant brings them to the execution for pedagogical purposes. Kafka's often playful and often tormented comments about children inhabit the walls of the room.

This notion of a "chronotope" is key to understanding the installation. "Chronotope" identifies a literary construction that describes representation much like a photographic depiction of an image. It is an image-idea, an Imago. Images abound in our installation, including words on the wall used to represent images. The chronotope is a space-time objectification of non-conscious memory-experiences that the self projects and arranges in space and time. The images function like a language, contiguous with the many other chronotopes. They are the building blocks of experience. They are the shadow of the objects around us. So the salon, the street, the road, the monastery, the conceptual architectonic arrangement of ideas etc., can have a memory function without our consciously knowing it. Cubism, montage, collage and new music are examples of

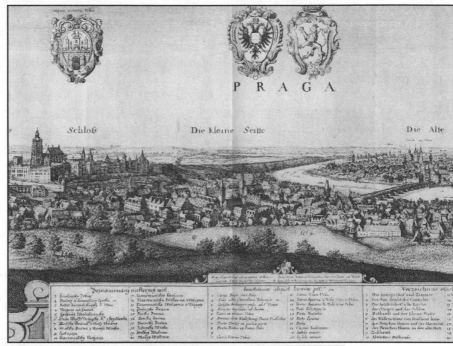

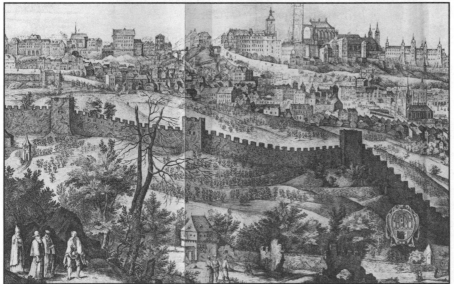

Prague Hunger Wall, Filipe van den Bosche panorama of Prague including sections of the Hunger Wall, 1606. Hunger wall constructed in 1360 - 1362 by Charles IV as a works project for the hungry, poor and unemployed. Was a defensive rampart as well as boundary. Reproduction in Collection Vaclav Cilek, Prague, with Permission. Prague Hunger Wall and Panorama, Filipe van den Bosche panorama of Prague including sections of the Hunger Wall. 1606.

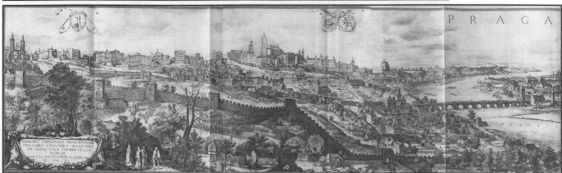

art movements that sought chronotopes or conditions through which a work could be brought to life and communicate its form and function. The literary work as a model for depiction in works of visual art is of course common. Clearly this can be related to the dreamwork in psychoanalysis where the structure of the dream frames an objectivized set of relationships that exist as immanent and latent content. I use Mikhail Bakhtin's extended construction as found in *Speech Genres and Other Late Essays*.[12] While this can be understood as a psychology of consciousness in Bakhtin, he is looking for something stronger than just the Platonic "image". The image is related to the *eidos* in Greek, which is way of visualizing an idea or theme or trope. On this basis Gilles Deleuze and Felix Guattari, break new ground in *Kafka: Toward a Minor Literature*.[13]

Puzzling as it may have been for spectators wanting to "see" Kafka, my intent was to present scenes that evoke empathy for objects and empathy for writing about a terrible event, torment that we shrink from as we struggle for an interpretation of violence defined as the invasion of the integrity of the person. That is why the walls of the Gallery were filled with sentences from his work. This reactivates the force of Kafka's writing. By confining it in a space, transience becomes the key to the relationships of objects that are collected in the room where Kafka never appears. Only the transient effects appear. In his world it was important to produce a material depiction of physicality and transience in the present. For example, there is the table with an open drawer of cotton batten that is the analogue of the bucket of cotton that has a thin red and blue line of blood placed nearby. Kafka describes this palpable material in his story using his sense of the uncanny life of objects. The chair and the table are replicas of those shown in the documentary photograph of the concentration camp of Theresienstadt's (Terézin in Czech) Small Fortress office. Beneath the picture is a replica of the chair and table plus a clock with the hands stopped at twelve. Unless we know how to read the shadows and light coming into the depicted room, we have no idea whether it is night or day. On the walls of the office are the pigeonholes containing the inmates' files. To the left of the picture on the wall is Kafka's aphorism "A cage goes in search of a bird." This aphorism is repeated elsewhere in the room. Once one builds a penal colony, or work camp, one has to find the labourers to inhabit it. In addition, there is a construction of my own devising, "Double Sided Kafka", in which a news item is sandwiched between two glass plates. The article is a banal report from the back page of an everyday newspaper

12 Bakhtin, Mikhail, *Speech Genres and Other Late Essays* translated by Vern W. McGee, Austin, University of Texas Press, 1986.

13 Deleuze, Gilles and Guattari, Felix *Kafka: Toward a Minor Literature*.

reporting that some letters of Kafka's had recently been discovered. The entire scene reeks of anonymity. The torment of a work camp is displayed as if it is simply a matter of office routine. The many connections of the commonplace to torment, show Kafka as an anarchist sympathizer. For some viewers this anarchist, anti-militarist scene could be the political heart of the installation.

» "THE INSTALLED DOUBLE ROOM"— KAFKA'S WRITINGS ON THE WALL IS A LAST WILL AND TESTAMENT

The origin of the installation *The Insurance Man: Kafka in the Penal Colony"* was in my wish to preserve a view built-up during the many years I have read Kafka, taught his works and written about him. At the same time I know that Kafka's gift to us may be the notion of transience, what Freud called *Vergänglichkeit* or impermanence.[14] For both Freud and Kafka this means to live in space-time scenes that function like a landscape where we are faced with loss, even the loss of loss, where we struggle to confront our mourning for that which was precious to us. To create a room in which impermanence is installed is to come to terms with Kafka and his presence. The story that portrays organized violence in "In the Penal Colony"

14 Freud, Sigmund, "Vergänglichkeit", *Gesammelte Werke*, Band X, London, Imago, Frankfurt, 1946.

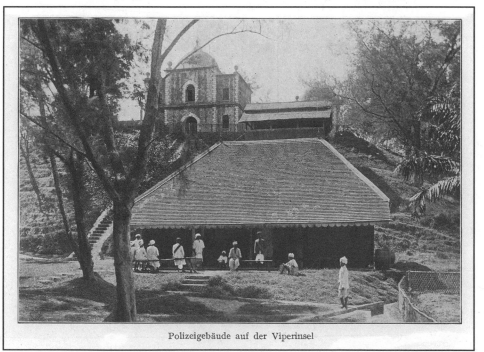

Polizeigebäude auf der Viperinsel

My Journey to the Penal Colonies, Police Headquarters on Viper Island page 384.

is then turned into impermanence through facing the objects and the inner relationship of the images in the room to Kafka's story, where the ultimate violence is the invasion of the inner domain of a person by force masked as law. While I am not a conceptualist, this installation attempts what conceptual strategies have made commonplace: to challenge the gallery as a system where art happens and the autonomy of art is challenged yet maintained as a given, even when reportage "about" art is included. The gallery as an idea also allows for an epistemological break with the museum; so the gallery can be a theatrical set, a site for a utopian project. Put another way, coming to terms with my memory of Kafka allows me to build into the untranslatable Kafka, an homage to his own challenge to literary form. Walter Benjamin understood the exact relationship of collecting to memory:

> What is decisive in collecting is that the object is detached from its original function in order to enter into the closest conceivable relation to things of the same kind. . . Plato shelters the unchangeable archetypes . . . and loses himself, assuredly. But he has the strength to pull himself up again by nothing more than a straw; and from out of the sea of fog that envelops his senses rises the newly acquired piece, like an island.—Collecting is a form of practical memory, and of all the profane manifestations of "nearness" it is the most binding. Thus, in a certain sense, the smallest act of political reflection makes for an epoch in the antique business. We construct here an alarm clock that rouses the kitsch of the previous century to "assembly". [15]

It is not well known that Benjamin was busy writing about Kafka in essays, sketches and letters throughout Benjamin's life. He saw the significance of Kafka's work for understanding his own thinking. Behind the active metaphor of collecting in the installation is the reality that Kafka lived when he traveled among many rooms. The writing on the walls and the central object, the pile of beds, represent these thoughts as his internal writing laboratory. Writing is Kafka's labour, his primary job. Almost everything he writes relates to labour and how others work and toil. It is labour to read him and labour to understand the writing on the walls. This is Kafka's secret. Reading for Kafka is the beginning stages of labour: he relates labour to being wounded.

> I read Hebbel's diaries (some 1800 pages) all at once, whereas previously I had always just bitten out small pieces that struck me as insipid All the same I started to read consecutively. At first it was just a game,

15 Benjamin, Walter, "The Collector", *Arcades Project*, translated Howard Eiland and Kevin McLaughlan. Cambridge, Massachussets. Harvard University Press. 204 -205.

but eventually I came to feel like a caveman who rolls a block in front of the entrance to his cave, initially as a joke and out of boredom, but then, when the block makes the cave dark and shuts off air, feels duly alarmed and with remarkable energy tries to push the rock away. But by then it becomes ten times heavier and the man has to wrestle with it with all his might before light and air return. I simply could not take a pen in hand during these days. Because when you're surveying a life like that, which towers higher and higher without a gap, so high you can scarcely reach it with your field glasses, your conscience cannot settle down. But it's good when your conscience receives big wounds, because that makes it more sensitive to every twinge. Altogether, I think we ought to read only the kind of books that wound and stab us. If the book we are reading doesn't shake us awake like a blow to the skull, why bother reading it at all? So that it can make us happy, as you put it? My God, we'd be just as happy if we had no books at all; books that make us happy we could, in an emergency, also write ourselves. What we need are books that hit us like misfortune that pains us, like the death of someone we loved more than we love ourselves, that make us feel as though we had been banished to the woods, far from any human presence, like suicide, a book must be the axe for the frozen sea within us. That I believe.[16]

The interior is thus the frame, and the objects that are displayed are both real and transient in the tradition of what might be called 20th century mannerism. The creation of a tableau using a room as both a settlement and a laboratory allows the room to function as a retreat from life's noisy phantasmagoria. The *Room* is, then, a double room: both an interior set and a dream that fabricates the history of his story within the room.

This is the third tableau I have created as enactments derived from literary works. The others were "The Measures Taken" after Brecht's *The Measures Taken*, Simon Fraser University Theatre, 1973, and "Dialectical Snapshots Against 1984", Carnegie Centre, Vancouver, 1984. These were conceived in part because of my interest in Peter Weiss and his *Aesthetics of Resistance* as well as my study of Benjamin, Bakhtin and the role of depiction in literature and art. The inspiration derives as well from Aby Warburg's attempts to find synchronic relationships across cultures and art forms in order to disinter experience from ritual form. In this sense the Gallery becomes a place of ritual.

Kafka used "history" in the way that the stories contain a concept of

16 Kafka, Franz, "Letter To Oskar Pollak", January 27, 1904 in *Letters to Friends, Family, and Editors*, trans. Richard and Clara Winston, New York, Schocken Books, 1977, 15 – 16.

Flucht-Statistik Neukaledoniens				
Jahr	Gesamtzahl der Sträflinge	Zahl der Flüchtlinge	Zahl der Wieder-verhafteten	Definitive Fluchtfälle
1864	247	14	14	—
1865	245	4	4	—
1866	345	15	15	—
1867	621	24	14	10
1868	1554	115	112	3
1869	2032	116	108	8
1870	2300	66	73	5
1871	2681	81	80	6
1872	3120	75	75	3
1873	4221	124	114	10
1874	5542	156	136	20
1875	6235	171	145	26
1876	6802	157	141	16
1877	7537	148	145	3
1878	8125	284	244	40
1879	7948	403	376	27
1880	8103	709	670	39
1881	6507	584	560	24
1882	6776	394	371	23
1883	7051	886	826	60
1884	7122	949	930	19
1885	7146	409	400	19
1886	7498	720	684	36
1887	7135	758	729	10
1888	6569	619	594	25
1889	6383	735	700	7
1890	6001	641	621	26
1891	5841	459	454	12
1892	5403	474	440	15
1893	5218	297	299	23
1894	5078	240	213	25
1895	4876	175	163	13
1896	9417	180	169	11
1897	9677	248	186	62
1898	9214	501	457	44
1899	8147	385	378	7
1900	7637	350	341	9
1901	7157	166	136	30
1902	7344	795	183	39
1903	6890	127	72	55
1904	6486	63	26	30
		211		14*

My Journey to the Penal Colonies, Table showing Flight Statistics from the Penal Colony, New Caledonia including those recaptured and those not yet caught, 1864 – 1904. page 211.

history as the experience of time and space. History is read from the point of view of its contradictions, continuities as well as breaks, and how dreams enter into history. For example, the key aphorism in the installation, placed strategically near the beds and next to the photograph of the Terézin/Theresienstadt "Lager" or Concentration Camp Office, is "A cage goes in search of a bird".[17] If one builds a penal colony one will have to find, or even invent prisoners and workers to put into such a colony. Kafka's stories and novels take place in rooms and confined spaces; narrators are disguised as authors who peer out of windows at the life being lived outside in the shelterless expanse of abstract spaces with recognizable landscapes. Of course for Kafka there were no free "natives or workers" who live in some land beyond the Insurance Company or outside the factories he examined in his day job. No wonder Kafka was attracted to stone quarries and walls as repositories of the past that had become petrified until the art of the "axe" of memory uncovered the images of labour buried there—as if behind the walls of a closed up room.

The installation is "After Kafka", but is not "post-Kafka". There is no actual depiction of the story itself as one might find in a film or dramatic replica. Instead it has affinities to the Marxist inspired film *Class Relations* (written, directed, and edited by Danièlle Huillet and Jean-Marie Straub), which is a Brechtian treatment of Kafka's *America* that renders the novel as a remote dream but does not show it as dream-like. I engage with the question of why in "In The Penal Colony" one can find both solace and inspiration in a mimetic relationship with another artwork in order to illuminate its aura, thus furthering its truth by locating aspects of its immanent material reality.

In this case, "In The Penal Colony" struggles with the violence of Kafka's world that gnawed in his head like the mice he feared and wrote about. The story is a *memento mori* even to the point of hinting at the flagellant tradition of pain and martyrdom common in Western art that depicted the punishment of criminals, or those who violated the faith of the true believers. Images of violence in art were most often seen through religious depictions that took place outside of Europe. Religious paintings of peoples in exile are not uncommon, but most often represent peoples in flight or expulsion;

17 Kosselleck, Reinhart, *The Practice of Conceptual History, Timing, History, Spacing Concepts*, Stanford, Stanford University Press, 2002 for a scholarly view of this idea of conceptual history.

Installation View Music Score of "After the War", in Travel Trunk "Amerika—The Nature Theatre of Oklahoma". Trunk contains Charlie Chaplin Hand Puppet. Photograph courtesy of SFU LIDC.

but images in art of penal colonies or prisons are to my knowledge very few and certainly stories related to penal colonies are rare. Dostoevsky's *Notes from The House of the Dead* is the one great exception. It is possible that Kafka knew of illustrations of Siberian exiles and penal colonies, as he knew of Heindl's book. However, the tableau in the room does not represent violence as such, but re-enacts the culture's resistance and attraction to violence. The foundational context for this tableau is the relationship of art to politics in the age of wars and martyrology depicted from Callot and Goya to graphic portrayals of massacres in World War I journalism. This is referenced in the installation in several ways: a wall display of Ernst Friedrich's *Krieg against Krieg*. 1924, [*War against War*] a pacifist's Callot-like depiction of atrocities in WW I; and by representations of industrial labour and mining labour depicted in several drawers in the vitrines.

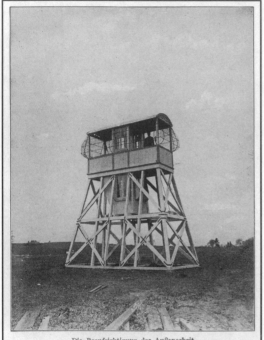

Die Beaufsichtigung der Außenarbeit

My Journey to the Penal Colonies, Observation Tower for Prisoners Doing Outside Work, New Caledonia, page 220.

Other representations of violence in the installed room include story book images from the penal colony itself that are depicted by placid, idyllic photographs in a DVD projection from two travel books known to Kafka, but primarily by showing the actual book, *My Journey to the Penal Colonies*; some photographs from Heindl accompany this essay. The ethos and tone of Heindl, reminds one of Alexander von Humboldt's classic *Personal Narrative of a Journey to the Equinoctial Regions of the new Continent* (1807–1827). Humboldt was the model of a progressive sympathizer of enlightened revolution who emulated the Directorate in the French Revolution in his belief that scientific rationality would answer the fanaticism and superstition of the ancient regime. This regime of violence was played out in France in the trial of Alfred Dreyfus and by the "Blood Murders" trials of innocent village Jews. Kafka's story and the installation present this resistance in the homicidal comic-grotesque form of the machine that torments the soldier—who has committed only the crime of insubordination—relying on the meditative distancing aspect of the story that teases us with a legal-philosophical discourse about a murder. Philosophical distancing

is subsumed by the choral device of Kafka's narrator, that is the basis of Hegel's understanding of the comic referred to below in the discussion of films that re-enact the baroque aura of Kafka's work. In particular one thinks of Orson Welles' *The Trial* (1962) that illuminated the catastrophes of the concentration camps, the Nuremberg Trials and Hiroshima-Nagasaki through film-noire stylizing of Kafka's references to the hidden force of law, shown in various measures throughout our installed double room. Information related to images and materials in the installation were referenced in the Gallery for the installation but are not republished here; for example the Dreyfus Affair, The Beiliss "Blood Murder" trials, and Octave Mirbeau's *The Torture Garden*.

» RESISTANCE AND TRANSIENCE

At some point in our lives we face the dilemma of the explorer who arrives "In the Penal Colony": when does opportunism become compliance and subservience? How many ways are there to obey, whitewash, surrender to the system; to deny and then lie while learning to live in the grey zone of obedience to the force of law? This is the ethical-political basis of Kafka's tale. Documents, objects and historical images can only reach this zone of complicity if we see that the novel is "an axe for the frozen sea within us." Story in the installation is also installation as story; part parable, but also part prophecy and part gesture. For Kafka, it is the story of his own resistance to being an author.

Kafka's works are scenes. They are not nightmares, nor are they macabre as are the works of Alfred Kubin that were familiar to Kafka (Kubin's images are shown in several books in the vitrines), scenes that capitalize on the distance and proximity of the everyday and commonplace. I

Eine Zellentür Zellentür geöffnet

My Journey to the Penal Colonies, Cell, "Cell Closed", "Cell Open". New Caledonia, page 43.

wanted to convey the convergence of the archaic and the modern that
reminds us of the phantasmagorical quality of Kafka and at the same
time his realism. The grotesque in this sense is an outgrowth of man-
nerism. It allows us to see that the grotesque is the art form that best
represents a response to the movement of early capitalism into baroque
forms of social control; the story and installation, contain many repre-
sentations of force and violence. The aesthetic point is to show resistance.
The installation "resists" Kafka and his own resistance to his work while
revealing measures of resistance in his leap into an almost metaphysical
"comic-grotesque" denial of progress in the arts, all the while maintain-
ing the musty atmosphere of the commonplace. In his work he appears
faceless, as if it were derivative of and the object of, scientific inquiry. He
does not retreat into phenomenology by maintaining his relationship to
familiar objects: thus the ethos of montage and colportage in the Instal-
lation. Along with Walter Benjamin, the figure closest to this working of
the streets of the ordinary is Ernst Bloch, who sketched out a position
on montage, kitsch, non-contemporaneity, relativism and objectivity in
Heritage of Our Times, [18]

The story "In the Penal Colony" is one of Kafka's purest represen-
tations of resistance made irresistible. All of his works are connected

18 Bloch, Ernst, *Heritage of our Times* translated by Neville and Stephen Plaice, Berkeley
 and Los Angeles, University of California Press, 1991. The book was first published
 in 1935.

*My Journey
to the Penal
Colonies*, Book
Printing Press,
New Caledonia,
page 240.

Buchdruckerei

directly to both the natural and artificial worlds around him. Yet the feelings that emerge are of a reality that is becoming posthumous, forgotten. The memory of pain and suffering shown metaphorically by the torture machine is only relieved by the images of writing as transience, nearness and farness. Writing is the basis of the machine's difficulty in remembering and holding onto torture. The machine implodes. The "look" or aura of the project conveys the archaic nature of our reality as well, as creating a feeling of non-contemporaneity. We need the axe of the novel to open the frozen sea of the memory

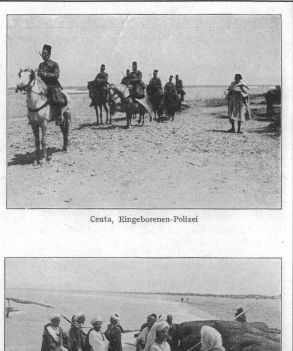

Ceuta, Eingeborenen-Polizei

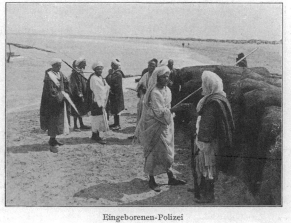

Eingeborenen-Polizei

of torment. The materials used around the machine convey the idea of fragility: also skin, glass and light suggest movement and fragility. Most are from my own collection or have been created and assembled for this installation. I chose the word "torment" over torture to ensure that the installation is seen in art-historical perspective. Torment is ironically Kafka's distancing perspective, used throughout the story to place torture in relation to history in art. Torture is often portrayed with crowds observing an execution because it reinforces not only law but also the participation by onlookers in the preservation of authority. Torture and/or execution is located in full view of the commons. In Kafka's story the viewers are the Explorer and the reader as well as the soldier and the populace of the colony. However the workers, who are in the Inn at the end of the story, barely know what's going on and are more interested in

My Journey to the Penal Colonies, Ceuta, Indigenous Police, page 284.

the Explorer than the day's proceedings.

The films made in the aftermath of the popularization of Kafka elaborate in various ways the philosophical bases of Kafka's stories. In the Gallery this was contextualized through portraits, beds, palm trees, X-rays, contemporary travel books that he loved, classic children's books, *Heimat* books and objects familiar to Kafka such as material from Hasek's *Good Soldier Svejk*. *Heimat* is an almost untranslatable German word that refers to the domestic communal location of language and customs belonging to the village, home and household. The suffix—heim is attached to many German town names, Mannheim etc. ('ham' in English towns). The point here is that the room is a home where care takes place. Odradek, in the "cares" of a family man, is embedded in the ethos of the Explorer's growing concern for what is happening in front of him.

All of these domestic objects are placed in vitrines under glass to remind the traveler-viewers of those exotic installations in museums where open drawers display and preserve the archaic, the lost, the miniaturized and the out-of-context. Also shown are a number of period books that have relevance to the theme of torment as a *memento mori*. For example Octave Mirbeau's *The Torture Garden* brings the tableau into the realm of the immanence and transcendence of pain. The polarities of childlike innocence and fear can be found in the story itself in the way the narrator and the Explorer experience the violence of the machine-that-resists-being shown yet feels homey as well as bizarre—almost a Rube Goldberg contraption.

The image of torment in the installation represents both force as law-preserving violence (in Walter Benjamin's use of the law in his essay "Critique of Violence") and the forces that evade and deny that force of law.[19] In Kafka's case what is left of the force of law are the anecdotal parable-like stories that are not written down as law but are transmitted through stories—voices internal to the culture. This leads the story into both psychological and philosophical terrain. For example, we can understand Kafka's comic sensibility through Hegel's "unhappy consciousness", revealing as it does the denial of violence at the heart of civilization itself. At the same time, as the Explorer learns, we encounter the ways that we can deny violence. My assumption is that the viewer must be capable of seeing that the violence in the story should not be translated into a specific replica of the machine that has frightened so many readers, including the first audience that heard the story in Munich in 1917 in a rare, for Kafka, public reading. Equally, the effort is to steer away from representations of Kafka as in Martin Kippenberger's *The Happy End of Franz Kafka's Amerika*

19 Benjamin, Walter, *Reflections*, edited by Peter Demetz, translated by Edmund Jephcott, New York, Harcourt Brace Jovanovich, 1978.

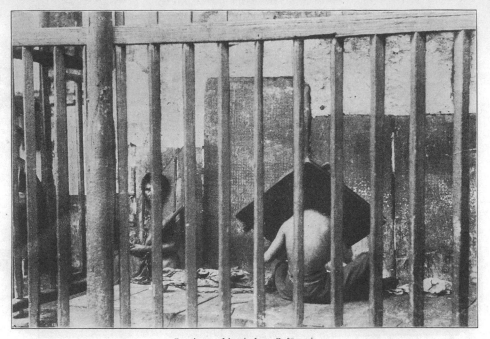

In einem chinesischen Gefängnis

(1999), or representations like the apocalyptic-fantastic which indulges in the search for the mystery of Kafka in some end-time political Messianic techno-fantasy, as in Soderberg's film, *Kafka* (1991).

My Journey to the Penal Colonies, In a Chinese Prison, Ceuta, page 321.

But since Kafka is alive as a universal character in our artistic repertoire he transcends the genres of the literary. One has to resist the trap of the Kafkaesque or the messianic-apocalyptic and not render him and his work into this or that, allowing him to be applied to everything that is bureaucratic, grotesque or prophetic. His stories are about "work"; they function as a language of situations that have the quality of work, of process, of the office, and of incompletion. Like great paintings or photographs, the work remains in the mind and comes back time and again without a specific name or label. The stories are in this sense a morphic landscape of memory.

Walter Benjamin referred to Kafka's work as "listening to tradition", which means the way tradition may lie hidden in the cave-like rooms where Kafka experienced his presentness. They contained his fear that he was fast receding into the obsolete. For this reason two paradigmatic works are important to the installation: Ilya Kabakov's "The Man Who Flew into

Space from his Room"[20] and Jeff Wall's "After 'Invisible Man' by Ralph Ellison, the Preface 1999–2001".[21] Both show rooms in which the dream of escape takes place in a construction that is on the edge of the phantasmagorical world where situations of the commonplace illuminate the strange in everyday life—in other words the aesthetics of morphic memory. The installation depicts the difference between the "everyday" as the quotidian and banal, and the "common situations" that are exaggerated in the dream world, and in the way individuals encounter themselves in the libidinal organization of a society.

Kafka knew that most of our lives are determined by the groupings in which we live; for Josef K. in *The Trial*, and K in *The Castle* these are hard lessons. Equally, the Explorer learns about resistance in his encounter with the Officer who yearns for recognition from the Commandant who governs the island. In Kafka the everyday is an artistic concept, in much the same way as the commonplace appears in art and literature in the 16th and 17th centuries in the context of wars of annihilation—Grimmelshausen's account of The Thirty-Years War is both a fictionalized-autobiography and documentary of a horrible war, and calamities of all kinds—a "Guernica". The situational and the commonplace are rendered into what appears as ordinary life-material. Exchange value becomes cultural value. The Explorer-Researcher finds his beliefs sacrificed to the purity of violence. The installation shows ordinary objects that become in their aesthetic reality exchange and fetish objects. Here the Explorer finds a pure group setting, perfect for researching what Europeans have made of the exotic colonies where groups act out their fantasies.

Freud's *Group Psychology and the Analysis of the Self* (1921) originates

Im Weiberabteil des Namhoi-Gefängnisses

My Journey to the Penal Colonies, Women's Section of the Namhoi-Ceuta, page 320. Ceuta was a Spanish Prison Island off Gibraltar.

20 Ilya Kabakov "Man Who Flew Into Space From His Apartment", 1985-1988 wood, board construction, room furniture, found printed ephemera, household objects, dimensions variable installation view at Ronald Feldman Fine Arts, New York, 1988. Photo: D. James Dee. Courtesy of Ilya and Emilia Kabakov and the Sean Kelly Gallery, New York. Reproduced on page 80.

21 Jeff Wall, "After 'Invisible Man' by Ralph Ellison, the Preface, 1999-2001", transparency in lightbox, 174 x 250.5 cm, Courtesy of the artist. Reproduced on page 80.

in the same post-war extreme situations as Kafka's story. Benjamin wrote in a letter to Gershom Scholem in 1938 (he had already written his major essay on Kafka in 1934) that Kafka was about transmissibility of its own failure and failure as such: "Kafka's real genius was that he tried something entirely new: he sacrificed truth for the sake of clinging to its transmissibility".[22] While Kafka hints at parables and the allegorical, Benjamin is right to say that his visual and conceptual representations are of the transitory and transient, their strength is to appear anecdotal. They challenge the force of law in the everyday and thereby establish that the commonplace in all its catastrophic terror exists in the reality of how this machine does away with people. This is why Peter Weiss connected Bruegel to Kafka.

The exhibition is also a dream room. The words that storm the walls in the installation are not placed there helter-skelter but according to the logic of how Kafka read his own torment in dreams and diaries *into* his writings. His words, are not meant to be read as if they are a direct route into the story, but as a colportage in the way they occur to him in a variety of circumstances, turning up to be repeated and worked through in his stories and his letters. One can't "read" words in a dream but one sees the affect of the words and the affect is a result of the transience of the images and our chasing after the images in the way the narrator-author of "In the Penal Colony" chases after—along with the reader—the reality of the Explorer and the Officer.

The Explorer experiences the torture event as both real and unreal in a display of doubt that what he sees can be a real. Walter Benjamin described this as the fundamental turn of the modern:

> This is the voice of the will to symbolic totality venerated by humanism in the human figure. But it is as something incomplete and imperfect that objects stare out from the allegorical structure.[23]

This is the sense of the physical and the immediately accessible, yet painfully remote quality of Kafka's diaries, experimental aphorisms, letters and drafts of stories that appear in letters and notes that were his laboratory, his totality. These were drafts, but were also memory traces in the manner in which Proust's memory was tolerable to him only as a theatrical tableau. Because Kafka is more of a trickster, a Hermes character who preferred the time-space location of crossroads and thresholds—rooms that

22 Brod, Max, "Kafka And Some of My Own Reflections", in *Illuminations*, translated by Harry Zohn, New York, Harcourt, Brace, World, 1968, 147.

23 Benjamin, Walter, *The Origin of German Tragic Drama*, translated by John Osborne, London, New Left Books, 1977, 186.

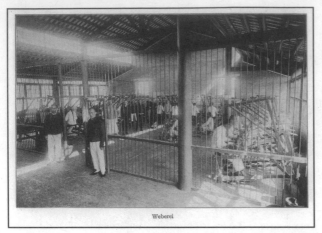

Weberei

My Journey to the Penal Colonies, Weaving Mill, Ceuta, page 324.

break into other rooms—he places his creatures and people into an dwelling-like structure, for example the cave or room in the head of the burrowing creature in the story of "The Burrow", which, like the machine in "In the Penal Colony", is an inner structure and a built-world. In this case a burrow is both a hole in the ground and a building with a hole in it. A room is the cave of his writing on the walls of his rooms, which is why there is double window in a constructed wall in the installation so we can look "out" of the room at the artificiality of the landscape seen through a window in an insurance lawyer's office.

In the installation there are many images of windows, walls, mines, and adventurous hiding places—including a set of 19th century graphics about robbers and their hideouts; these are derivatives of the phantasmal nature of the common violence that takes place in the story itself. Heindl's book on penal colonies becomes itself a window for Kafka because it describes and documents reformist penal colonies for the German State in the same way Kafka documented his own research into the political economy of factories.

The *Panorama of Prague* that stands behind the beds, that are the tormenting-objects-as-machine, is a picture of "The Hunger Wall" built in the 14th century, standing in part at the southern and western region of Petrin Hill in Prague. The Hunger Wall was constructed in 1360-1362 by the humanist-reformer Charles IV as a works project for the hungry, poor and unemployed. It was a defensive rampart as well as boundary. The writing on the walls in the installation fractures the formal space of the room in the way the wall itself has been broken over the centuries; in Prague today the wall appears as a theatrical tableau in which the viewer walks around and "sees" many of the objects that Kafka knew and then translated into the holes of his hunger-wall as memory traces. His writing reminds us of geometry and physics and in this way it depicts a "mythography" of time and space. Other artists such as Adolf Loos and Otto Wagner in the Austro-Hungarian empire, as well as city builders particularly in Vienna, were also working within the new abstractions of space by showing the connectedness of finite structures in the city to the feelings that

worked against the factory system and its bureaucratic phantasmagorias. Civil unrest and migrant peoples in the industrial and squalid sectors of cities contributed to the hope for revolution among the satellite peoples of Austro-Hungary. Vienna and Prague were cities waiting for revolution.

Kafka inserts himself into the genre of the novel in the way strangers come into culture, knowing that there is usually danger lurking within any culture. Simmel's now famous account of the wanderer explains the sense of dislocation and danger that Kafka's characters experience as their unknown known:

> If wandering is the liberation from every given point in space, and thus the conceptional opposite to fixation at such a point, the sociological form of the "stranger" presents the unity, as it were, of these two characteristics. This phenomenon too, however, reveals that spatial relations are only the condition, on the one hand, and the symbol, on the other, of human relations. The stranger is thus being discussed here, not in the sense often touched upon in the past, as the wanderer who comes today and goes tomorrow, but rather as the person who comes today and stays to morrow. He is, so to speak, the potential wanderer: although he has not moved on, he has not quite overcome the freedom of coming and going. He is fixed within a particular spatial group, or within a group whose boundaries are similar to spatial boundaries.[24]

Like Cezanne, Kafka moved the optical into a place of apparent confusion. Kafka regarded the inner world as terrain that had been invaded by forces never before imagined; he projected these forces onto the moving screens of an external world that was swiftly changing and being undermined by powerful forces such as the factory system and military weaponry. This was the end of verticality and the thinking that allowed vertical construction to become a symbol of the gods. It is also the end of the "horizontal" sense of time that evolves and develops; thus resistance occurs at both ends of the spectrum of space and time. Modernism is the result of those artistic inventions.

WW I violently overwhelmed the precarious forms of resistance to law and the force of law, depriving the emerging revolutionary-Syndicalist movements of the vocabularies and experiences of transformation, being felt by the masses. The sense of force registered by the machine in "In the Penal Colony" is depicted by the mattresses in the installation: Writing bed, Hospital bed, Travel bed, Office bed, Machinery bed and at

24 Simmel, Georg, "The Stranger" in, *On Individuality and Social Forms*, edited by Donald N. Levine, Chicago and London, University of Chicago Press, 1971. page 143

the entrance to the Gallery the tubercular Death bed. Letters from Dr. Robert Klopstock are displayed in the vitrines. Klopstock was the Doctor who was with Kafka toward the end of his illness.[25] Klopstock recognized that Kafka had X-ray vision into the substratum of consciousness that leaked through the gaps of the built-world: some X-Rays are shown in our room. The commonplace situations that history brings to the doorstep and thresholds of our encounters are situations that can terrorize us because they may not have meaning until we recall the objects that make up and surround terror. This includes objects that have no use until one finds a use for them. In regard to the material, haptic qualities of Kafka's stories, Walter Benjamin understood the materiality of the tableau of memory in his own work, and his essays on Kafka reveal how deeply Kafka influenced him. In "The Interior, The Trace" section of *The Arcades Project* (212) Benjamin writes:

> *The importance of moveable property, as compared to immovable property. Here our task is slightly easier. Easier to blaze a way into the heart of things abolished or superseded, in order to decipher the contours of the banal as picture puzzle—in order to start a concealed William Tell from out of the wooded entrails, or in order to answer the question: "Where is the bride in this picture?" Picture puzzles as schemata of dreamwork were long ago discovered by psychoanalysis. We, however, with a similar conviction, are less on the trail of the psyche than on the track of things. We seek the totemic tree of objects within the thicket of primal history. The very last—the topmost—face on the totem pole is that of kitsch.*[26]

The Explorer-Researcher comes to the island as a world traveler, a world-flaneur who learns to observe human behaviour in extreme situations. The question raised is whether the Explorer will return to his previous life as the same person who left Europe to write reports about penal colonies and their material qualities—"the thicket of primal history" and "wooded entrails". The portraits looming over the beds and on the nearby walls conveyed this question. The traveler-researcher who came to the penal colony to observe something he has only read about in books, comes away having observed himself. Reproductions of coloured woodcuts of idyllic folkloric scenes of adventure and storybook robberies are shown in the installation as well as in the vitrines. In a demonic reversal of ethnographic observation, the machine that is supposed to execute the prisoner has been transformed into beds that prefigure in

25 Klopstock, Robert, *Kafka's Letzte Freund* [Kafka's Last Friend], Wien, 1993.

26 Benjamin, *The Arcades Project*, 212.

layers of torment everything that the protagonists cannot reveal of and to themselves. The object here is to show torment without the horror and brutality of torture. In the story that is what the machine is actually doing by inscribing the words "Be Just" and "Obey your Superiors" on the body of the prisoner.

Because Kafka compiled his impressions as if they had no beginning or end, they appear as assemblages of raw materials that occur in the contiguous plastic manner of the dream. The Room is both dream as supplementary (*nachträglich* in German also means aftermath) interpretation of the story as well as a complementary chain of connections and contiguities coming together as a room of transitory objects. The path through the installation leads eventually to the vitrines and the drawers that contain ethnographic materials in the manner of relics in an anthropology museum or map room, and then the very books that Kafka used as source materials are shown as totems on a television.

» **EVERY ROOM HAS AN OUTSIDE**

"Everyone carries a room about inside him. This fact can be proved by means of the sense of hearing. If someone walks fast and one pricks up one's ears and listens, say in the night, when everything round is quiet, one hears, for instance, the rattling of a mirror not quite firmly fastened to the wall."[27]

The Room should also be seen as a dream room that resists overt surrealist features. In Kafka the dream dreams the dreamer. The writer uses the dream situation as if the dreamer didn't exist and in this way the world outside of the dream becomes contiguous with everyday life. So his writing functions as a reverie or daydream. The window in the wall opens up as a dream-like object because it shows a lawyer's office in Vancouver where last wills and testaments are spread on a table. But the wills are, like art, illusion.

The story is not only an ordinary dream but is a tabooed self-representation that cannot be duplicated. To believe in the machine the way the Officer cajoles the Explorer to accept it only makes the viewer feel complicit in the execution: thus the beds are material objects that have metamorphosed out of the Explorer's story into visible illusions complete with a battery (depicted in the story), which in the installation is connected to the mattresses and to the Officer's genitals. One can't ever duplicate a dream! This is why Freud believed in the autonomy of the artwork as a

27 Kafka, Franz, "The First Octavo Note-book", in *Wedding Preparations in the Country and other Posthumous Prose Writings*, translated by Ernst Kaiser and Ethne Wilkins, London, Secker and Warburg, 1954.

reality-dream. In Kafka's stories, affect appears to be absent. The reader has to work at it, just as Josef K in *The Castle* or K in *The Trial,* have to work at what is happening to them. That way 'dream work' is a totality that resists being broken down. The dreamer who speaks about the dream should be able to realize some aspect of the unconscious that the dream resists. For Freud a theory of dreams can't be understood without the most difficult aspect of psychoanalysis: resistance. This installation accepts the story but also resists making it into a Kafkaesque theatrical extravaganza.

What does this set regarding "In the Penal Colony" mean in terms of my own reading of the story? In the set Kafka disappears as a figure in a *mise-en-scene*. We can imagine that he films himself somewhat in the vein of the unfinished novel *Amerika*. We know Kafka travelled everywhere throughout Bohemia and also walked the off-the-beaten tracks of Prague. He travelled to Munich where he read the story that was conceived while living in different rooms; much of his life was observed with his camera eye while moving and traveling. Noting what passed in front of his window was always a literary and aesthetic possibility. So the "room" is also a traveling compartment—the window is the screen through which one watches the actors who are collaborators in one's imagination: the phantasmagoria of Kafka's everyday life flashes by. It is a re-enactment or recasting of the story, similar to what Benjamin means by dialectical images that add up to a "profane illumination" of what was once "sacred" (i.e. memory) and has now become integrated into the destiny of the common situations we live in.[28]

Wall Collage,
Jerry Zaslove.

28 One should reference the "Declaration on the Protection of All Persons from Being Subjected to Torture and other Cruel, Inhuman or Degrading Treatment or Punishment" of the U.N. Resolution of December 1975. See the contribution in this book by Tom Morris.

The scene in the installation that refers to the Terézin camp and the office in which the documents were held and organized is referenced not only because Kafka's sisters were murdered in Auschwitz after their imprisonment in the Terézin camp, but because of the legal apparatus that was used to identify and classify files to permanently extinguish everyone in all but their names and numbers. The set becomes an enactment of the narrator's position in the story, the cultural shock of seeing and denying that what he is encountering is the result of European civilization's most recent account of itself in the work, life and relationships that Kafka lives in the "room" called Prague. As I have pointed out, the set is a colportage of "transitional objects", or inner images, that come to life under certain conditions of remembering, when trauma does not intervene to cause amnesia about violence. The Narrator-Explorer experiences a form of trauma, expressed as denial, and it takes time for him to contain and assimilate what he is seeing as an experience, not just a sensation.

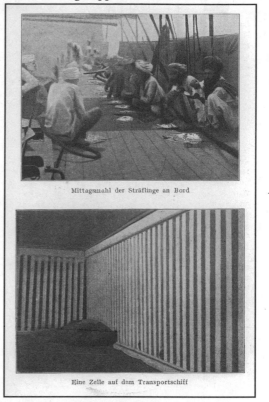

Mittagsmahl der Sträflinge an Bord

Eine Zelle auf dem Transportschiff

The beds are labelled to show that the story cannot escape the embedded nature of the Explorer's sense of the onto-theological nature of the violence in front of his eyes. The writing on the walls is organized by keywords—noise, children, letters, memoirs, etc in bold. It was intended that the viewer read these texts that tormented Kafka. It is not possible to read these wall-writings in one visit to the gallery. The reader-viewer might come back again and again to a situation that Kafka confronts, namely the illegible nature of the "machine": the writing on the body of the ordinary man sentenced to death as a creature that is nameless. Most religions particularly Christianity see us as mere creatures influenced Kafka in his stories and fables about humanized animals and animalized humans. Voices of children were incorporated very quietly into the installation by using tracks from *Brundibár, An Opera for Children*, composed by Hans Krása, and performed in Theresienstadt (Térezín) concentration

My Journey to the Penal Colonies, Top: Mid-day Meal of Prisoners on Board Prison Transport Ship, page 332. Below, Prison Cell on Transport Ship, page 332. .

My Journey to the Penal Colonies, A Chinese Prisoner on the Andaman Islands, page 333. Below: Indian Criminal Type, page 333. Note the mirrors that provide a profile view

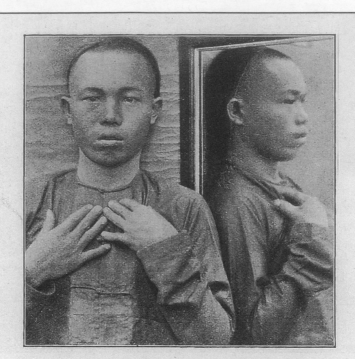

Ein chinesischer Sträfling auf den Andamanen

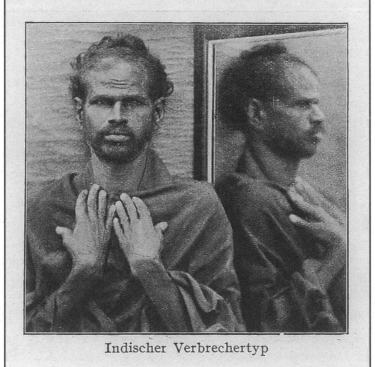

Indischer Verbrechertyp

camp. In addition, Czech songs sung by children were heard. The object was to show the purity of children's voices under these circumstances. Elsewhere in the installation depictions of Kafka's awareness and attitude toward children were posted on the walls.

So I see the story itself as Kafka's confrontation with the violence in life around him and the in-built nature of that violence in the world that he sees both near and far from his windows. The Room is his "camera"— his apparatus—a set like all of Kafka's stories. We look outside through the brightly lit window in the wall this is related to Kafka's meditation on "The Street Window" and "The Wish to Be a Red Indian". Primitive accumulation in the Colonies masks the laws of ownership. This is also the fate of Karl Rossman who palys his part in the "Oklahoma Nature Theatre" in the novel *Amerika* which was written before *In the Penal Colony*, but uses the same theme of a traveler confronting a colonial world of work. "Oklahoma Nature Theatre" the concluding utopic trip in *Amerika,* assures the reader and Karl Rossman that in the "nature theatre" everyone will have a job. It will be a workless world of work. In the installation, the American Dream and The American Phantasmagorical future are shown in the traveler's trunk that is situated at the foot of the bed next to the masked Officer, who stands over the bed and the trunk. This shows the continuity of work to penal colonies and penal colonies to utopia. The trunk contains patriotic paraphernalia including an important translation of *Amerika* (1946) with an introduction by Klaus Mann who later became a friend to Dr. Robert Klopstock who he consulted for his various addictions.

The colonies are about collecting, hoarding and the archiving of laws and people. They reveal the deepest logic of capitalism, preparing everyone for the Second Coming of the Millennium of Progress by collecting and storing whatever is not destroyed by the machine world. The system of violence is camouflaged as a way of life. But the Officer reveals the heart of the matter—becoming the "hero" of the story. This is the Hegelian heroic portrayed as that which "feasts on its own offering, that itself is the Fate to which the secret is betrayed, no matter what may be the truth of the independent substantiality of nature."[29]

The description that the Officer gives of the machine (posted at the doorway to the installation) is a sign that this machine can only be imagined. The Explorer sees the machine but is unable to read the blueprint, and this is the beginning of the suspicion that the machine might go awry. The machine does go berserk while seeming to contain a self-conscious knowledge of violent wars of both the past and present. The legacy of

29 Hegel, G. W. H., "Ethics and Tragedy", in *Hegel on Tragedy*, ed. Anne and Henry Paolucci, New York, Anchor books, 1962, 299

Prügelapparat

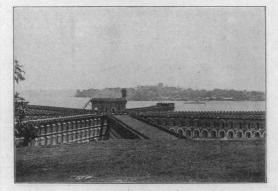

Das Aberdeen-Gefängnis

My Journey to the Penal Colonies, Top: Cudgel/Thrashing Apparatus, page 337. Below Panorama View of Aberdeen Prison, page 337.

this religious warfare is found in the Strahov Monastery near the Prague Castle, its library depicted on the Panorama where a photograph of Monastery books are seen as captured objects. Kafka's office writings are housed in a building adjacent to the Strahov Monastery in the Czech National Literary Archives.

The ethical-political meaning of the self-consciousness of the Explorer is related to the portraits of the Prague cultural dignitaries staring down at the beds. Facing the beds on the opposite wall are portraits of ordinary people. These are portraits of Rodin-like heads that I liken to "The Burgers of Calais". They are models from the Prague School of Fine Arts; the artist Bozena Kozakova painted the figures during the period of the story's conception. Since *Kafka In the Penal Colony* is about a face-to-face encounter with another human being, while others watch the spectacle of the execution, it is important to have a scene where others watch this extreme and ludicrous situation. The everyday horror extends to the detail of the handkerchief in the Officer's belted uniform. The forceful and panicked interrogation of the Explorer-Researcher by the Officer plays with the concept of order and fate. These startling images bring the reader-viewer to see the reality of the Explorer and the Officer who encounter each other as adversaries. The portraits impress me as pietistic, internalized concentrations of vital energy. The visages are stern and look upon the beds of torment without apparent emotion. But this is deceiving. The background to this empathy for the victim is informed by the radical dissenting nature of the Hussite martyr-religion with its long historical life in Bohemia. This form of dissent can be closely aligned with the Protestant radicalism of Hegel and his theory of tragedy and comedy. The portraits of cultural figures: actors, writers, actresses and political figures who were known to

Kafka and his contemporaries hang on the opposite wall. By placing them in the installation the images represent the figures in the story who fix their eyes upon the execution. Their eyes are the counterpart to the eyes of the pietistic onlookers torn by conflict. The unspoken question is who can trust what they see?

The masks placed on the two mannequins should be understood as gestures. One represents the Austro-Hungarian Officer, the other the ladies whose handkerchiefs adorn the Officer's uniform. Masks disguise and reveal the philosophical underlay of Kafka's sleight-of-hand philosophy that takes refuge in trickster forms of humour. The Officer and the Explorer experience a psychological transference in each others' wish to avoid what is going on before their eyes. The Explorer doubts that the Officer's self-abandonment can be meant seriously, and the Officer doubts that the European onlooker can see the virtues of his machine.

We begin to have some sympathy for the Officer because he acts out the love of violence—a taboo that the culture hides. We guiltily participate with the Explorer by watching the progressive diminution of the Explorer's confidence that he should know what it is that he is seeing. The Explorer doesn't show disgust, only frustration and he becomes dizzy when his hold on his consciousness weakens; however he does see that this is a "murder" and not a trial.

Kafka was thoroughly familiar with the deportation of the poor and immigrants to the edges of the "Universe", whether the outreaches of Siberia or the Pacific Islands. The deportation of convicts was a standard civilizing "journey". He heard lectures from law professor, Hans Gross, who argued the virtues of deportation. Hans Gross, the jurist father of Otto Gross the renegade psychoanalyst, was the author of the classic book on criminal anthropology and deportation. He committed his anarchist-oriented Dada son to a psychiatric institution. Kafka and Otto Gross had planned to create a journal on the subject of the will to power. It is easy to imagine that Hans Gross is the "Old Commandant"; but it is the subject of deportation, exile, and criminal typing that brings Kafka to this subject. The Explorer sees the consequences of his own culture vividly acted out by the Officer, who insists he is carrying out the orders of the Old Commandant to make the prisoner *Unschädlich*—harmless. The Officer revels in his certainty that he is administering a humane punishment. To render someone "harmless"—in all its meanings—provides the Officer with anticipation and excitement. Thus, connecting the battery cable to the officer's genitals in the installation reverses the image of the Officer's demands by showing his masochism.

Readers often bring up religion or symbolic meanings in the story.

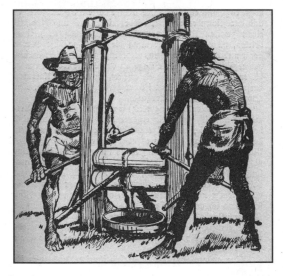

Der Zückerbaron—Schicksal eine ehemaligen Deutsche Offfiziers in Süd Amerika, 1914. ("*The fate of a former German officer in South America, 1913*). Green Band Collection, Hermann Schaffstein, Köln,n.d., Collection Jerry Zaslove

It is certainly a way to see a larger metaphysical dimension to the attraction we have to sacred violence and the denial of our social and individual complicity in watching power acted out. But only through the critique of religion can we see his realization that writing on the body documents symbolic sacred meanings. The words on the walls are Kafka thinking, including thinking about religion. In writing down the law, the law becomes clearer for what it is: a violent—and in the Officer's case—aestheticized Dada-like machine that transmits this sacrifice through writing. This is Kafka's comic-grotesque critique of violence in religion—when the execution fails the Officer falls apart.

The locale, as in all of Kafka's nondescript and misleadingly abstract scenes, is precisely rendered so that we see the familiar in the totality of the unfamiliar. The subreal surfaces seem utterly normal until one actually sees what is happening. Cotton batten in the desk drawer symbolically depicts the Terézin Concentration Camp and the bucket that collects the prisoner's bodily fluids is used to show this palpable material that lies at the base of the story's object-oriented obsessions. The problem faced by the Explorer-Researcher is how to take seriously the fear that fills the scene. Astonished, the narrator and the reader watch the Guard and the freed prisoner dance around the event of a murder—not of the prisoner, but of the Officer—"I am the narrator of the penal colony". In other words there is another "voice" in the room, the compiler-author who builds the *mise-en-scene* and gives the viewer an image of the abstract nature of the event, whose words "Obey your Superiors" and "Be Just", are not, in the end, inscribed on the body of the victim. That voice is the voice in the room. I wanted the participants who came to the installation to become that narrator. Filmmakers seem to have understood the relationship of Kafka's work to scenes, adaptation, improvisation, and collecting. Sets often use the compilation of materials to illuminate the particular and general in his thought. We know the locale, but can't quite recognize or name it, although it has precise contours and we know we have been there, but we feel safer in denying it.

» **KAFKA AND HEGEL—TWO COMEDIANS**
 OF THE DEAD SPIRIT
The attraction to Kafka for filmmakers began in the post-war period with Orson Welles' *The Trial* (1962). But "Kafka and film" began with Kafka's own visits to movies. Hans Zischler's account of Kafka's film habits make a strong case for the mise en scene tableau approach that I am taking.[30] Kafka's consciousness of film and photography might be

30 Zischler, Hans, Kafka Goes to the Movies, trans. Susan H. Gillespie, Chicago and London, University of Chicago Press, 2003.

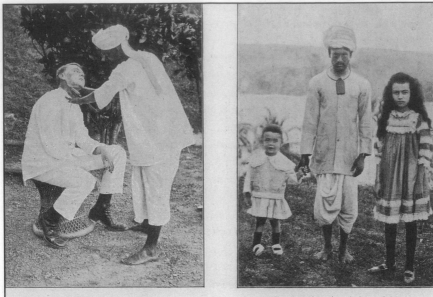

Der Mörder als Raseur Der Mörder als Kindermädchen

My Journey to the Penal Colonies, Murderer as Barber and Murderer as Children's Maid, Penal Settlement, Andaman Islands off of the coast of India, Probably Fort Blair

described as his "Speaking Eye", owing to his astonishment at the use of the photograph. He expressed this in his letters by frequent allusions to the photograph, especially in his correspondence with various women; in this regard his own "speaking eye" might be called the "The Eye of Sancho Panza" after Kafka's several references to Panza.[31] Sancho Panza often appears in Kafka's thinking—a point not lost on Walter Benjamin. The reference here to the "speaking eye" is also to Wayne Burns' *A Panzaic Theory of the Novel*. Burns was one of the first to use Kafka as the basis for a material theory of the novel. Hegel too, understood that the unhappy consciousness is the material mask of fate put on by the self:

> *The self, appearing here in its significance as something actual, plays with the mask which it once puts on, in order to be its own person; but it breaks away from this seeming and pretence just as quickly again and comes out in its own nakedness and commonness, which it shows not to be distinct from the proper self the actor, nor again from the onlooker."*[32]

31 Burns, Wayne, *A Panzaic Theory of the Novel*, The Howe Street Press, 2009, with my Introduction, "To the Future Readers of this Book: Who's Afraid of Sancho Panza?" Also see Wayne Burns, "'In the Penal Colony': Variations on a Theme by Octave Mirbeau", Accent, XVII, 1 (Winter, 1957), 45-51.

32 The Self-Conscious Language: Comedy", in *Hegel on Tragedy*, edited with an Introduction

Sancho Panza is or pretends—we are never sure—to be the fool whose fate is to interpret on his own body the idealistic consequences of the law-abiding Don Quixote. For Adorno and Horkheimer in *Dialectic of Enlightenment* the Quixote Principle is understood through Odysseus, the man whose life is "determined by domination" and who is "the prototype in the hero who escapes from sacrifice by sacrificing himself . . . in other words the history of renunciation."[33] The room that Kafka refers to in his notebooks, cited at the opening of this essay, is the setting through which the eye notices what the mind only later comprehends. The room provides an angle of vision, an aperture, the world made distant and near, hidden and secret, as well as at the same time natural. The photograph is the prototype of the totality that always recedes into the distance while promising nearness. The photograph functions like a silent mirror.

Kafka's Father's Fancy Goods and Notion Store, Prague. Reproduced with Permission of Klaus Wagenbach Verlag, Berlin

It was easy in post-war America to assume that Kafka's work belonged to the expressionist traditions of early film. The films of Kafka's work appeared on the scene simultaneously with the paranoia and surveillance mentality of the Cold War and fear of Communism. The investigation of exiles and dissenters was part of the landscape of political terror. Steven Soderberg's *Kafka* (1991) uses this ethos, but unfortunately the public awareness of the Cold War had vanished by 1991. However, because of Max Brod it became evident that Kafka was himself being observed through biography, as if the works were only understandable through his life; the question of translation from one medium to another allowed Kafka to become "Kafka", both writer and observer tarrying in the sinister rooms where space and time are alienated from any hope that might extricate the observer from what the observer sees. In this sense the Explorer-Researcher is an Odysseus-figure who lands on an island that bears the mark of a degraded totality; an island where renunciation of ethical justice acts out a pure-survival existence disguised as utopia.

Allegorical readings of Kafka, even of those who reject Kafka through rigid Marxist analysis, as Georg Lukács did in 1962, opened the dispute over Kafka.[34] Many Marxists (Ernst Fischer for one) have read Kafka creatively, as did the Frankfurt School authors whose work is indebted

by Anne and Henry Paolucci, New York, Anchor Books, 1962, 299.

33 Horkheimer, Max and Adorno, Theodor W., *Dialectics of Enlightenment*, translated by John Cummings, Allen Lane, London, 1972, 55.

34 Lukács, Georg, *The Meaning of Contemporary Realism*, London, Merlin Press, 1962.

to Kafka. Günther Anders, a radical phenomenologist who studied with Husserl, was one of the first to recognize the depth of Kafka.[35] However, it was Arnold Hauser who saw that Kafka was a Mannerist and that his work is similar to a waking dream, that lends itself to cinematic enactment.[36]

Rooms, space and time, contiguities and extended metaphors, architecture and the built-world of the city, walls, bridges, streets, and the outsider's view of degraded humanity became chronotopes that lead naturally to film. These qualities come through in films such as Straub's *Class Relations*, a Brechtian version of Kafka's novel *The Man Who Vanished into America*, and later Michael Haneke's *The Castle*.[37] Both fall within the axis of the Frankfurt-Augsburg-Berlin films of Alexander Kluge that originated with Rainer Fassbinder's films and slightly later Peter Weiss's *Marat/Sade*: these were historical chronicles of the German wars determining the historical pathos of the commonplace as the everyday. Meaning is stripped of theatricality even as the theatre as an institution is used to show the epistemological divides in seeing, remembering and forgetting. Filmmakers appreciate stories, but while Kafka breaks through story; he seems to attract the cinematic. The cinematic, *mise en scene* is so open to the art of reverie, compilation and colportage, as well as to allegory understood as Benjamin reads allegory—with epistemological eyes.

"In the Penal Colony" takes place in the full daylight and in this sense can be related to the alien vision of Mannerist art, when the theatrical is contiguous with the Baroque plays of mourning. The character of Karl Rossman in "The Man Who Went Missing" (re-titled *Class Relations* by Straub/Huilet who adapt Max Brod's artificial title *Amerika* for Kafka's unfinished work) exists in a world of loss. It is in fact a loss of loss emerging somewhere between fetishism and phantasmagoria that plays at the edges of baroque allegory in the way that Walter Benjamin describes allegory as the genre that brings into view the creature stuck in the mirror of the theological-juridical mode of thought. Benjamin, in *The Origin of German Tragic Drama*, states that "The creature is the mirror within whose frame alone the moral world was revealed in the baroque."[38] Benjamin is surely thinking of Kafka when he writes in the *Arcades Project*:

35 Beck, C.H., *Franz Kafka Pro et Contra*, Munich, 1951.

36 Hauser, Arnold *The Crisis of the Renaissance and the Origins of Modern Art*, Alfred Knopf, New York, 1965. Also more directly about film, Hauser's "The Film Age" in *The Social History of Art*, vol. IV, New York, Vintage Books, 1951.

37 These films along with several shorter films were presented at the Vancity Theatre, June 1st–July 6th, 2009 under the title "Kafka in the Dark—The Strange and Sinister Cinema of Franz K."

38 Benjamin, *The Origin of German Tragedy*, 91.

Allegory recognizes many enigmas, but it knows no mystery. An enigma is a fragment that, together with another, matching fragment, makes up a whole. Mystery on the other hand, was invoked from time immemorial in the image of the veil, which is an old accomplice of distance. Distance appears veiled. Now, the painting of the Baroque—unlike that of the Renaissance, for example—nothing to do with this veil. Indeed, it ostentatiously rends the veil, and, as its ceiling frescoes in particular demonstrate, brings even the distance of the skies into nearness, one that seeks to startle and confound. This suggests that the degree of auratic saturation of human perception has fluctuated widely in the course of history. (In the Baroque, one might say, the conflict between cult value and exhibition value was variously played out within the confines of sacred art itself.) While these fluctuations await further clarification, the supposition arises that epochs, which tend toward allegorical expression, will have experienced a crisis of aura.[39]

The best Kafka films re-enact and juxtapose allegory, story and image by depicting the immanent meanings of Kafka's work. The films are a moving *mise-en-scene* and bring the reader in through the alienating quality of monastic sparseness and proximity that illuminates the lives of the characters. This functions in an anti-theatrical mannerist form in both Straub/Huillet and Haneke. Karl Rossman in *Class Relations* is related to the Explorer-Researcher in *In the Penal Colony*. He observes the surface of things. He floats. He watches. He denies authority its right to coerce him, but he goes along in a classical Svejk-manner that exposes the ridiculous. The Explorer-Researcher notes the common situations he encounters on the island as much through curiosity as through fate. It is culture shock of the kind Kafka, as ethnographer of the city, experienced every day. The same shock affects the Explorer-Researcher until he abandons the island.

Kafka would frequently vanish on his excursions into the suburbs and countryside of both the Germanized and Bohemian towns. His ethnographic eye carried and treasured his own sense of exile in "going missing" just as the poor peasants and shopkeepers who manned the castle beneath its walls in Haneke's *The Castle* existed in a propertyless, space waiting for the revolution to unmake their lives. The Land Surveyor, "K" who comes uninvited into their walled village and intrudes into their very rooms, is a nuisance reminding the people of their own comic-serious complicity and subservience to the castle. The Divine law is both material and comic. The Explorer comes into the penal colony as K comes into *The Castle*. In the penal colony there is no divine law, only the banality of the machine and

39 Benjamin, *The Arcades Project*, 365

the tradition of the underling, prisoner and worker extending for centuries into the past. Kafka was well aware of the class alignments and the Feudal arrangements that led from the landless peasantry to the landed and religiously opportunistic gentry's reorganization of Feudal privilege. The transcendent and burgeoning bureaucracy mediated the transition from Feudalism to Statehood. This became the philosophical basis of Kafka's comedy: *mise-en-scene* was a way of life.

In Haneke's film, *The Castle*, the castle doesn't exist just as it doesn't exist in the novel. The messages from the castle are garbled. Klamm, the director of the castle's operations, doesn't appear. The people live a *mise-en-scene* existence. Klamm's directives are mere notes that torment the people who read them, just as the Officer's blueprint of the Machine torments the Explorer. Writing is laughably false redemption. Writing should break the spell of the disease of civilization that makes a proud and strong people, but instead joins with the castle's silent authorities and weakens our defences against the Klamms and the castle. We see this in the opening scenes of Haneke's film. Writing, like marriage, is the ultimate sacrifice of the body to a force that has no name. The castle, writing, and the women become themselves "transitional objects"—they embody messages and hopes and temporary erotic attachments—but the castle engineers the split of inner objects that come and go. The writing harbours a dream for the future, the dream of reaching the castle. This corresponds with the Officer's dream of total redemption through his "writing"—his sacred blueprint for a violence that in the end is denied redemption.

Welles' expressionistic version of the messenger at the door of Joseph K's room in *The Trial* is a microcosm of the comedy of the philosophical need to render terror into the comedy of immanent danger, and to turn violence into a comical justification of law. In *Class Relations* The Oklahoma Nature Theatre is the farcical utopia that releases us from Karl Rossman's penal colony. The beds in the installation—the tormenting mattresses—function comically as the impossible-what-is-happening here on the mattresses. Catastrophic violence is just around the corner. Welles' *The Trial* is a baroque period piece that could support a Benjaminian interpretation of an "emptied world":

> *The baroque knows no eschatology; and for that reason it possesses*
> *no mechanism by which all earthly things are gathered together and*
> *exalted before being consigned to their end. The hereafter is emptied*
> *of everything which contains the slightest breath of this world and*
> *from it the baroque extracts a profusion of things which customarily*
> *escaped the grasp of artistic formulation and, at its highpoint, brings*
> *them violently into the light of day, in order to clear an ultimate heaven,*

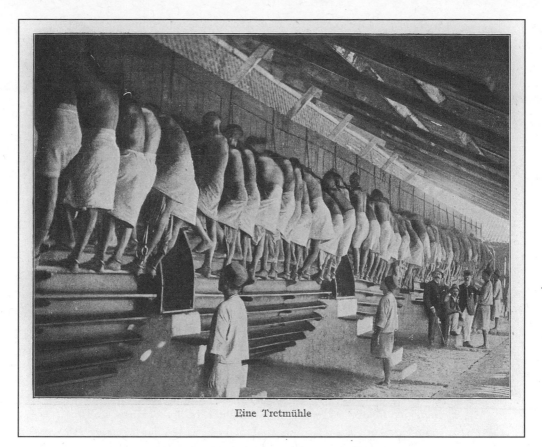

Eine Tretmühle

enabling it, as a vacuum, on day to destroy the world with catastrophic violence.[40]

The scenes in *The Castle* show the artificial nature of the village: snow, water, rooms, corridors, and the goofy assistants—the lost Odradeks —who try to tell K something but deprive meaning of its essential substance. At the end this leaves us hoping to wake up into another life where we are all free. That would be the Oklahoma Nature Theatre where everyone has work but also some inkling of care as in "The Cares of the Family Man" [Odradek] where K's kindness toward the humiliated subverts the degradation that he sees, except he has no vocabulary to describe it. This is the reason why there is an "Oklahoma Nature Theatre" travel trunk at the foot of the beds in the installation. The "kindness" or compassion in Kafka registers in the way the author sees what is happening to the figures, characters in the fables, the creatures, the animals, stories, etc. In my reading of the story it is almost an act of

My Journey to the Penal Colonies, Treadmill, Andaman Islands, page 449.

40 Benjamin, *The Origin of German Tragedy*, 66.

'kindness" for the Explorer to leave the island because if he were to stay he would fear becoming a person just like those on the island. Kindness is all we have left in the world and it is rationed out for those who have hope not for us, but for the hopeless, to paraphrase Kafka. This anarcho-ethics is echoed in Haneke's *The Castle* but it is so muted that no critic that I know of really sees the wretched resignation of the people to the castle—like people today living in barrios who are faced with working at avoiding a degradation no one had ever been able to imagine.

An unknown future is captured in the illusion of uncertainty in the cinematography of both Straub/Huillet and Haneke. In order to reflect Kafka's passion for the everyday that exists outside his window I included in the installation five small 19th century Xylographic hand coloured newspaper illustrations of the kind of outdoor scenes that Kafka treasured. They are from a book entitled *From the Sketchbook of a World: Robbery in a Silvermine; Birdseye View of Oostende; Saltmine Wieliczka; Coin Washing; A Mine.* Travel books that he is known to have treasured are in the vitrines.

» EPILOGUE: THE SHADOW OF THE OBJECT OF KAFKA

At the beginning of this essay I cited Haneke's comments about his films and his mode of depiction: "How do I give the spectator the possibility to become aware of this loss of reality and their own participation in it in order to emancipate oneself from being the victim of the media by being its possible partner?" Similarly I have characterized Kafka's "In The Penal Colony" as having a philosophical outlook toward violence when that outlook comes into what might be called "performance": to find a way to show his work visually by seeing its provisional qualities, their traces, as if in a photograph.[41] The viewers of the installation become, in Hegel's world, the chorus. To explain this briefly, it means that Kafka was sensitive to the fact that unknown forces were displacing the theocratic state, which had provided a looming collective consciousness. For Hegel, self-consciousness occurs when the actor, split from the mask reveals the fate of both mask and actor. The chorus is the crowd of onlookers who become aware of their own latent comic-consciousness when the mask no longer protects the illusory character of the conscious individual in all its "nakedness and ordinariness".[42] Kafka's Explorer-Researcher suddenly sees the Officer wearing the mask of what Hegel calls "the legal recognition" of the unfulfilled person: the

41 Kracauer, Siegfried, "Photography," in *The Mass Ornament, Weimar Essays*, translated with an Introduction by Thomas Y. Levin, Cambridge and London, Harvard University Press, 1995, 62.

42 Hegel, G. H. W., "Ethics and Tragedy", in *Hegel on Tragedy*, ed. Anne and Henry Paolucci, New York, Anchor Books, 1962, 299.

Officer is a grotesque imitation of a human being.

Kafka's narrator shows that the Explorer-Researcher has what Hegel calls "Stoic independence of thought", but in passing through the "dialectic of the Skeptical Consciousness" it "finds its truth in that shape which we have called the Unhappy Self-consciousness", which is "the counterpart and the completion of the comic-consciousness". In order to reach this self-consciousness "the ethical world and the religion of that world are submerged and lost in the comic consciousness, and the Unhappy Consciousness is the knowledge of this total loss." This total loss, which I would call the "loss of loss" in Kafka, is what Hegel notes as the "loss of substance as well as the loss of Self, it is the grief which expresses itself in the hard saying that 'God is dead'". Hegel writes as if anticipating Kafka: "In the condition of right or law, then, the ethical world and the religion of that world are submerged and lost in the comic consciousness, and the Unhappy Consciousness is the knowledge of this total loss".[43] The history of torment that is depicted in paintings since the 15th century provided the public with the aesthetics of the spectacle of public executions. In "In the Penal Colony" this loss of a public world of pain and brutality expresses the hope for the elimination of the theocratic state, itself a penal colony complete with spectacles of public executions and privatized compliance with violence.[44] The execution of the insubordinate soldier and the immolation of the Officer take place in the outdoors away from judicial scrutiny, making a mockery of justice administered through ordered systems of power.

The immanent nature of the comic-grotesque in Kafka lies in an anarchist radiance that emanates from his sense that the world is absent of any trustworthy legal or juridical justice. In the end of the story and in Kafka's world no juridical-theocratic solution is possible. That possibility has been scrambled so that no depiction can liberate the world from the loss of reality. The world that is created within the *Room,* in order to be ethnographically rich and sensitive to human activities that make the world, must be surrounded by Kafka's writing on the walls. The writing, on the walls then become a bureaucratic labyrinth like the bureaucratic writing on the walls of Kafka's office and in his head. The room built for *Kafka in the Penal Colony*—is "after Kafka"—it is a double room with elements of real life, concrete details that remind the viewer-reader of the other room that Kafka "erects", "an intricate scaffolding of dead elements revealing in their outward existence the language and the historical

43 Hegel, G.H.W., *Phenomenology of Spirit*, translated by A.V. Miller, Oxford, Oxford University Press, 455.

44 Hegel, *Phenomenology of Spirit*, 450 ff.

circumstances that replaced the inner elements of the ethical life that housed, created and inspired them".[45]

Many Europeans imagined their continent purified of extraneous criminal elements and ancient human sacrifices, and even imagined aboriginals as cannibals, while constructing penal colonies that cannibalized the prisoners, and grotesquely in Kafka's story, cannibalized themselves.[46] Gananath Obeyesekere, explores the cannibal myth in his account of how Captain Cook and other "explorer-researchers" in their tales of their travels to the South Sea Islands perpetuated the myth of canniballism.

While there is no evidence that I am aware of that Kafka read accounts of cannibalism, the German word for cannibal, *Menschenfresser*, or man-eater, is portrayed by the machine that consumes the Officer. The dry, official and statistically rich bureaucratic account of penal colonies in Robert Heindl's *My Journey to The Penal Colonies* does not conceal the cannibalism of the machine, and opens the story to the dead elements in Hegel's comic spirit. While livelier examples of the negation of negation can be imagined, they would have to encounter Kafka's creations that embody the phantasmagoria that fills the dream room of "In the Penal Colony".

Agonies in bed toward morning. Saw only solution in jumping out of the window. My mother came to my beside and asked whether I had sent off the letter and whether it was my original text. I said it was the original text, but made even sharper. She does not understand me . . . Through this and several other observations of myself I have come to believe that there are possibilities in my ever-increasing inner decisiveness and conviction which may enable me to pass the test of marriage in spite of everything, and even to steer it in a direction favorable to my development. Of course, to a certain extent this is a belief that I grasp at when I am already on the window sill. . . .

Diaries, August 15, 1913

Kafka's diaries

45 Hegel, *Phenomenology of Spirit*, 454 – 456.

46 Obeyesekere, Gananath *Cannibal Talk, The Man-Eating Myth and Human Sacrifice in the South Seas*, Berkeley, Los Angeles, London, University of California Press, 2005.

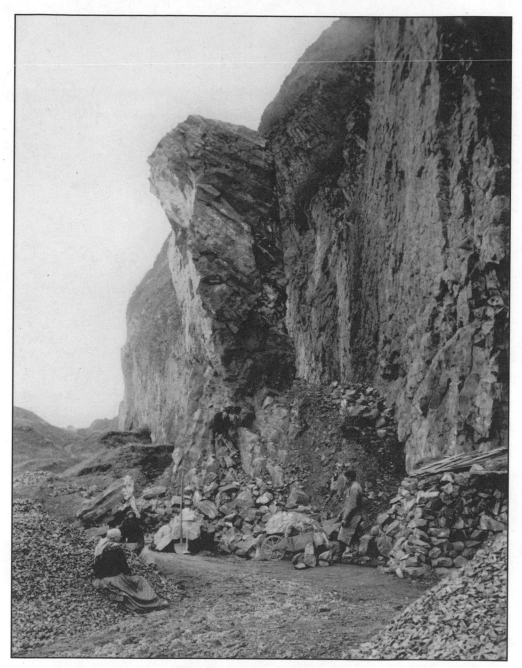

Quarry Reproduced with Permission of Klaus Wagenbach Verlag, Berlin. [Quarry reports by Kafka now published in *Franz Kafka: The Office Writings*, edited by Stanley Corngold, Jack Greenberg, and Benno Wagner, translations by Eric Patton with Ruth Hein, 2008.]

Oskar Weber:Briefe eines Kaffee-pflanzerZwei Jahrzehnte Deutscher Arbeit in Zentral-Amerika, mit Zeichnungen von Max Bürger Köln: Hermann & Friedrich Schaffstein [Letters of a Coffee Planter—Twenty Years of German work in Central America with drawings by Max Bürger.] Collection Jerry Zaslove

Installation view: Comedia Masks on mannequins. Reproductions of masks from 18th century baroque theater in Cesky Krumlov, Czech Republic.

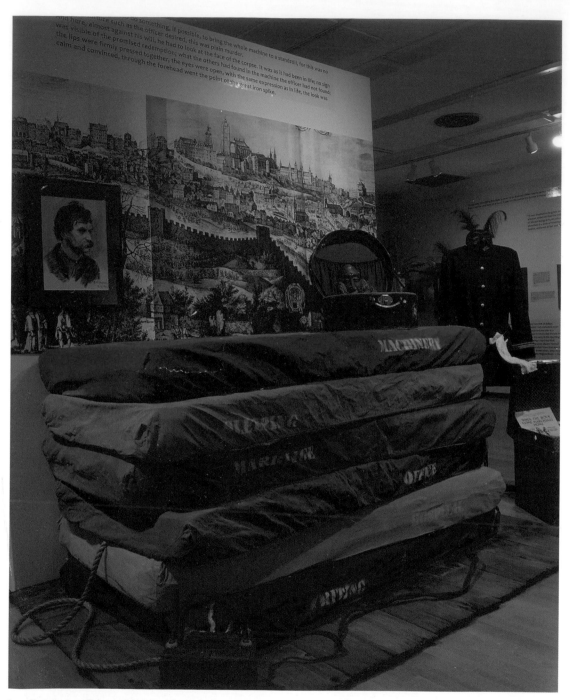

Installation view: Torment Machine The Beds; Prague Panorama, with trunk Amerika. Trunk with cultural ephemera related to Kafka.

THE OFFICER SHOWS THE LABYRINTHEAN BLUEPRINT DEVELOPED FOR THE HARROW MACHINE TO THE EXPLORER WHO CAN BARELY READ THE NOTES

Kafka's text has been reformatted here to a Set of Directions that echo the countless official documents he wrote and read and presented to conferences, his office colleagues, in the Prague Workers Accident Insurance Institute for the Kingdom of Bohemia one of seven such Institutes in the Austro-Hungarian Imperial realm. A list of some of these companies and concerns who were governed by a complex bureaucratic system can be found elsewhere in the room.

- Lots of flourishes around the actual script are needed
- The script runs around the body in a narrow girdle
- The rest of the body should be saved for ornamental marks
- Run up the ladder to turn the wheel if necessary
- Call to those below to beware the noise
- Watch out when coming down
- Look up at the Apparatus to check it out
- Follow the script if you can
- If it is not in working order climb back down into the pit and fix it
- Note that the Harrow writes the inscription on the back of the prisoner
- Slowly turn the prisoner over to allow for more free space for writing
- Deepen the raw wound that has been inscribed and staunch with cotton wool
- The teeth of the Harrow now tears the cotton wools from the wounds
- Pitch the wool into the pit so the Harrow can do its deeper work
- The writing work will take twelve hours
- Note that for the first six hours the condemned man lives merely as he did before
- He suffers only pain
- After two hours the felt packing is removed
- Note the man no longer has strength to scream
- Warm milk-rice from the electrically heated basin is set at the head of the bed
- The man can use his tongue to lap up as much as he wants
- Experience shows me us that few miss the chance to eat
- At about the sixth hour the man loses any desire to eat
- I usually kneel down to observe this phenomenon
- The man rarely swallows the last bite and rolls it around his mouth before spitting it into the pit
- Be sure to duck or it will come into your face
- The man will grow quiet in the sixth hour
- Expect Enlightenment to come to even the stupidest fool
- It begins around the eyes and spreads beyond him into a moment that could tempt oneself to get under the Harrow with him
- Nothing further happens except the man begins to decipher the writing and

Installation view: Blueprint.

Installation view: Wooden Ladder and Cotton Batten in a basin beneath reproductions of graphics by Ernest Freidrich, War Against War 1924.

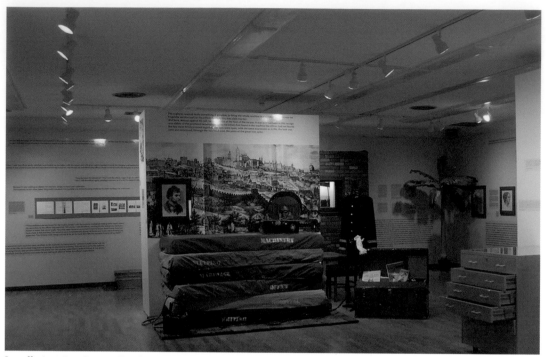

Installation view: Bozena Kozakova, Prague School of Arts. The Torment Machine with Prague Panorama, Battery, Officer and Beds of 'Machinery', 'Sleeping', ' Marriage', 'Office', 'Hospital', 'Writing,' Watched over by "Explorer". Charcoal and crayon. Photograph courtesy of SFU LIDC.

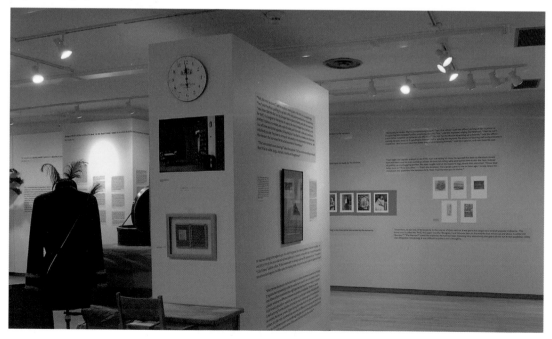

Installation view: Dirk Reinartz photograph Small Fortress Office, Theresienstadt Concentration Camp, with montage construction Double Sided Kafka, Sandwiched Glass Newspaper Clipping with 'Unknown Letter of Franz Kafka Found'. Montage construction Jerry Zaslove.

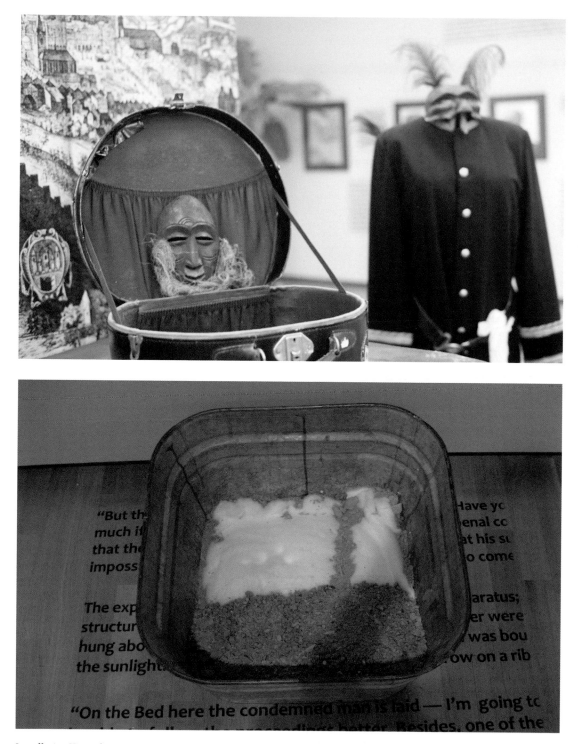

Installation View adjacent to Torment Beds, Nigerian Mask, Woman's Hatbox, Austrian Officer's Uniform with Handkerchief in Belt, and Basin with sand and cotton batten to catch fluids from Prisoner.

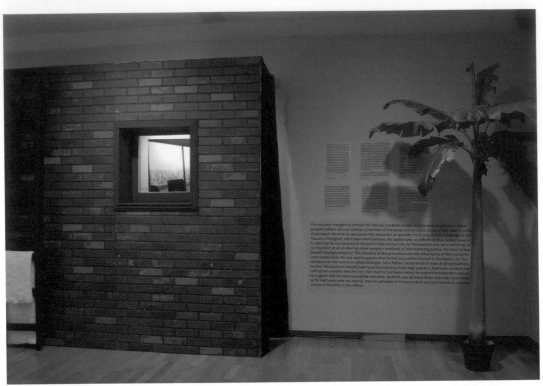

Installation view: "Construction of Wall and Ladder with Window of Insurance Company View of North Shore, Vancouver, with "Last Will and Testament'" Photograph by Jerry Zaslove

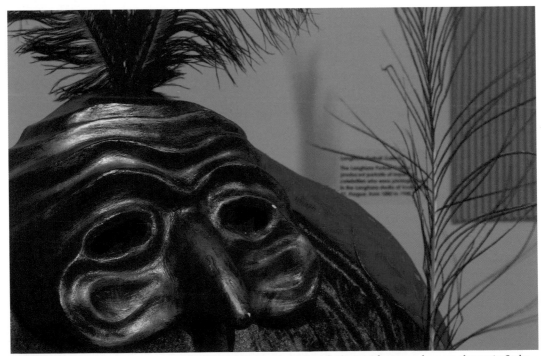

Installation view: Comedia Masks on mannequins. Reproductions of masks from 18th century baroque theater in Cesky Krumlov, Czech Republic.

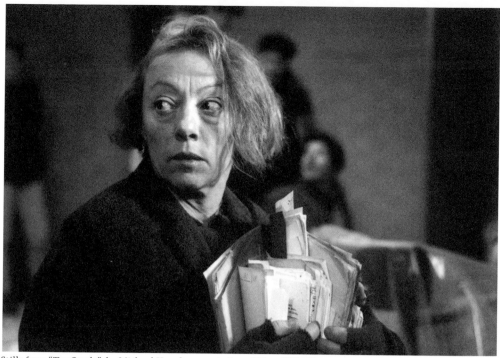

Stills from "The Castle", by Michael Haneke, permission of Wega FILM Vienna

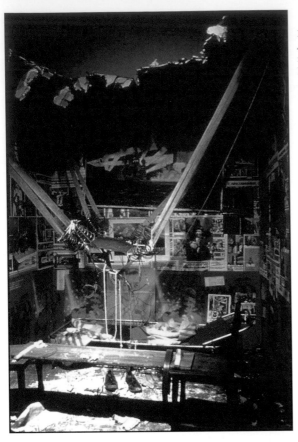

Ilya Kabakov. *The Man Who Flew Into Space From His Apartment 1985-1988*. Wood, board construction, room furniture, found printed ephemera, house hold objects. Dimensions variable. Courtesy of Ilya and Emilia Kabakov and the Sean Kelly Gallery, New York.

Jeff Wall, *After 'Invisible Man' by Ralph Ellison, the Preface 1999-2001* transparency in lightbox 174 x 250.5 cm Courtesy of the artist

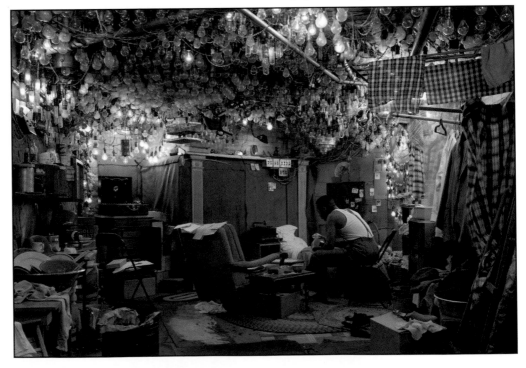

the KAFKA FILES:
Responses To The Installation

A view of the Kafka Family's Asbestos Factory Photograph Reproduced with Permission of Klaus Wagenbach Verlag, Berlin.

REACHING FOR THE VANISHING POINT

» KAIA SCOTT

"A cage went in search of a bird"*

The room housing the Kafka exhibit is yellowed, a bit like an image from an old book: it lends everything both a touch of warmth and an edge of brittleness. The simple trick of lighting gently tampers with the gallery's atmosphere, setting the room ever so slightly off kilter from the world outside. It is a fitting light in which to be presented with turn-of-the-century Prague through the lens of Kafka's tropical penal colony.

The penal colony in Kafka's short story appears at first to be more than just slightly estranged from the narrow stone streetscapes of Prague or other Bohemian towns where he himself worked. And though he left the details of this exotic island setting imprecise, the hot, sticky atmosphere that he creates is heavy and palpable. As the readers of In The Penal Colony become increasingly panicky and short of breath, they start to recognize the feeling as one that Kafka has made them feel before in very different stories. A million miles away from his civilized quarters in Prague, Kafka has transmuted the same claustrophobia of Bohemian social formality that is found in works like The Trial, into the "wild" and stifling air of the penal colony. Both his descriptions of this island in the sea and a labyrinthine office building in Prague feel equally hazy, oppressive, and just out of reach. Characters as quotidian as clerks, attending offic-ers, or salesmen, begin normally enough but soon begin to speak strange single-speaker languages or sprout papery wings, until they too, start slipping away from any imaginable reciprocal contact.

From the otherworldly spaces of Kafka's stories, the exhibit shares with visitors a simple and important truth. It is a collection of objects from the Prague of Kafka's era, images of tropical lands that would have been circulating around Europe at the same time, and Kafka mementos that have been gathered up from many times and places. It comprises an odd travelogue that wants to show us that Kafka's writing room and the heavy social matrix that held it in place is not as far apart from a distant island of European exiles, military personnel, and natives as it may at first seem. It composes its collection of objects with the hope of communicating that Kafka's stories of bureaucratic horror are not just unfathomable flights of genius imagination, but that they are inextricably bound to a brutally candid vision of the social machine that he lived in with all its pressures of work, love, family, politics, religion, class, race, and other social stratifications.

Kafka's stories present us with the gruesome spectacle of human spirits twisting in painful directions between institutions that can do nothing but disfigure them. The doubly sad revelation is that these institutions remain our only point of contact. For him, the girl on the bus with whom he falls in love in an instant of eternity cannot fail to become anything more than a wife, a mistress, or a shopkeeper. Even his discipline-hungry officer from In The Penal Colony longs desperately for human contact on his own terms. Inevitably though, the institutions that shape us make contact a vanishing point that draws everyone deeper into their own design. Contact's poor substitute becomes nothing more than a memorized affirmation and recounting of the institution's syphilitic creation story.

From the walls of the exhibit, the portraits of Prague's cultural celebrities stare in from one side, those of working class people from the other. Some walls are decorated in the designs of the industrial machines that were amputating Kafka's clients, others with political decrees and manifestos, and all of these face in toward a "bed" of personal pressures that Kafka likely faced. The room creates a visual lecture that reminds visitors that Kafka did not exist in some absurdist fantasy, but in conditions that for all intents and purposes have not changed so very much. The images whisper suggestions of present incarnations of the same institutions that twisted the urge for contact in Kafka's characters back in war-torn Europe. Through the collected mementos of Prague and locales like a tropical penal colony, the exhibit reaches toward a picture of Europe's brutal industrialization, savage imperialism, and disintegrating social conventions, while building a shrine to the fallout that gathers around us as we chase the vanishing point of contact with a ruptured history.

To a patient observer, the exhibit articulates the thoughtful suggestion that *In the Penal Colony* is a perfect vehicle for attempting this fraught contact. All stories contain the imprint of their time, but as a dictionary of human behaviour, this one could be chanted over and over again, like a hymn, to conjure up all the pieces of a language of civilization.

Like one might imagine of a bedchamber in a bourgeois household, the exhibit wants us to hear the sounds of a nursery drifting through the walls. The children are reading aloud: they are learning the stories they have been given by rote. A peaceful and powerful pastime, the stories both mold and provide fantasy. They are delight disguised as work, and work disguised as delight.

In the stifling heat of the penal colony, as in the claustrophobic density of the bourgeois nursery, the children are pushed in close, bul-lied by their surroundings to observe the strange customs of their world. As the puffing, sweating officer recalls, he used to personally see to it that the children were shuttled to the very front of the crowd so that they could take in, unobstructed, the deadly calligraphy of The Harrow at work.

When Kafka finally takes off the officer's sweaty gloves, and shows us The Harrow's obscene massacre, I cannot help but feel like one of the children: pressed in close, horrified, confused, amazed, and completely unable to look away. Of course the adult in me cannot help but breathe a secret sigh of relief, as the ladies in lace sitting safely behind the children must have also done after the punishments of the past: It was awful, but it had to be. Kafka has finally given us some narrative relief: the poor slave has been saved, the hideous torture-master slain, and the evil harrow has been destroyed. At least the mess is over, and justice has ultimately been served. The children however, remember that the ladies always feel this way at the end of punishment.

The Zürau Aphorisms, Trans. Michael Hoffman, New York, Schocken Books, 2004.

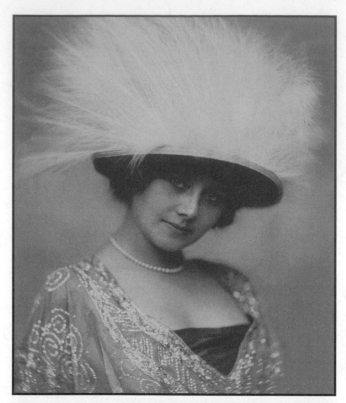

Anna Sedlackova 1911; Actress, Reproduced with permission Langhans Portrait Gallery.

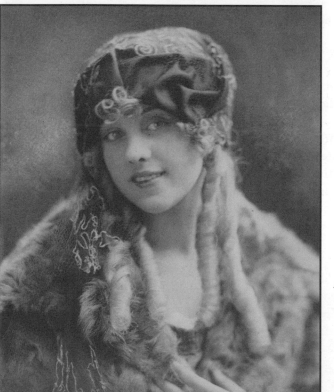

Anny Ondrakova, 1921 1921; Screen Actress. Reproduced with permission Langhans Portrait Gallery.

CURATING
THE VOID OF
COLLAPSED
MACHINERY

» ROB BROWNIE

In the Gallery an officer's garmenture is crowned with a feathered mask. Portraits of colonial masters and laboring slaves hang alongside images of machines that grind and extract. A stack of mattresses recalls aspects of Kafka's thematic oeuvre. The collection of artifacts displayed in the room suggests a memorial to an historic trial or perhaps the staging of a theatrical scene where some grand injustice is about to unfold. A rope awaits the fettering of limbs. Witnesses to the torture event look on from within their frames. Paradoxically, the more evidence I strive to examine, the further removed I am from reaching a singular view of the exhibit. A ladder rests against a wall inviting the always possible escape, which is rarely ever taken.

Walter Benjamin referred to Kafka's work as "an ellipse with foci that are far apart."[1] The writing is replete with fissures, wounds and ruptures which illuminate variations of the separation motif: the arbitrary nature of the law, alienation from authority, the culture of exile. In The Penal Colony takes this theme of dislocation to an obscene climax when the machine of the story disintegrates. As the animated gears scatter a kind of double wound erupts, repre-

sented by the fatal blow to the officer's skull but also the space vacated by the machine's departure. One imagines what the villagers might do with this site, if anything? What mnemonic potential is contained within the machine's absence? Memory, it would seem, may give way to superstition as we acknowledge the explorer's silence as he reads the inscription on the Commandant's gravestone. "Have faith and wait!"—a prophecy the villagers find ridiculous.[2]

Weeks after seeing The Insurance Man: Kafka in the Penal Colony I travelled to Berlin. Ruins, excavations, monuments and memorials mark the landscape at every turn. Berlin is a living archive, a national gallery of failed totalitarian dreams. The Berlin Wall was the progeny of Kafka's machine, a mad instrument of judgment and condemnation. The Wall, in fact, was a kind of vertical Bed with layers of apparatus to thwart escape: an inner Wall, barbed wire, electric fences, a dog corridor, control towers, alarms, anti-tank obstacles, a fakir bed (essentially an area embedded with raised spikes), and finally the outer Wall that marked the boundary between East and West Berlin. The effect of the Wall was to create a form of self-colonization—to preserve the paranoid fantasy of the ideal state.

The Wall produced its own expressions of the animalized human. By scurrying, climbing, ramming, burrowing or taking flight, many managed to flee successfully and yet hundreds were wounded and killed as they sought a way out of the state apparatus. Sections of the Wall and the gears that constituted the death corridor sprung off during the years after reunification. Pieces of the Wall were dispersed across oceanic divides while other sections have been aesthetisized as objets d'art. Like the Machine in the story, the collapse of the Wall has created a negative space with a multitude of readings; it is a scar, an emancipatory event, a place of remembering, longing, forgetting. As with the empty lot in The Penal

1 Walter Benjamin, "Some Reflections on Kafka," in *Illuminations- Essays and Reflections* (New York: Schocken Books, 1969), p. 141

2 Franz Kafka, "In the Penal Colony," in *Franz Kafka: The Complete Stories* (New York: Schocken Books, 1971), p.167

Colony, the question of reclamation arises- giving rise to the problem of what to do— what is the zoning potential of space named the "death strip"? How do planners curate the void of collapsed machinery?

In places the Wall is maintained as a memorial, elsewhere it is a trace distinguished as a line of masonry in the pavement. Along certain sections, the banks of the Spree River and facades of other buildings absorb the Wall seamlessly. With disbelief I came across evidence of a different kind of rezoning of the Wall-machine void. In Prenzlauer Berg a showroom for a housing development had been constructed within the Wall corridor, metres from an apartment building where in 1961 residents flung themselves out of third-story windows to reach West Berlin on the street below. The developer's slogan on the hoarding read, "Your New Home, WITHOUT COMPROMISES!" Further along the Wall in the Kreuzberg district the Fellini Residences were being sold under a similar premise, "You do not have to die to arrive in paradise. You have it right on your doorstep." The Wall has become the final frontier of post-colonial Berlin.

Kafka insisted on exploring those dissonant pauses that linger in human relations, urban spaces and the rule of the law—in order to make such voids visible. In turn, the Installation extends the memory of the machine as it responds to its absence. As with the Condemned man of the story, who remains condemned after his temporary reprieve, the Wall in Berlin remains embedded in the psychic-self of the city. The city is condemned to continuously re-invent itself and re-build its empty spaces and historic wounds. And yet it would appear that with reunification, in true Kafkan style, many Berliners have been left behind to suffer the same fate as displaced and confused villagers elsewhere. Viewing the Wall as an extended metaphor of the story it is evident that speculative forces have been re-colonizing the city and the effect is dizzying.

Interviewed twenty years after the collapse of the Wall a former border guard reflects on his memory of the collapse of the Wall:

"I wouldn't wish that on anyone. I more or less fell into a deep depression. I didn't want to go home. I stayed in the barracks. Everyone else had left. I stayed until the end. I didn't do anything, just stayed in bed [...] I drank beer and stared at the sky."[3]

3 CBC, "Berlin, 20 Years After", November 6th, 2009

THE INSURANCE MAN IN THE PENAL COLONY

» IAN ANGUS

Entering the installation one is confronted by a set of stacked beds named in descending order as machinery, sleeping, marriage, office, hospital, writing—hooked up to a car battery—layered like an archaeology of consciousness descending into un-probed but electrified depths. Why isn't Freud's picture on the wall, that other German-speaking Jew from the Czech lands? His absence might open our presence in the same way as Kafka's machinery of the 20th century unconscious. Through the window there is a picture of Vancouver against the mountains. Where is the unconscious of our world? Has the insurance man shed his troubled baggage in the New World? The end of history without the history that brought the end? I bought a book of matches with Kafka's face on it in the kitschy Kafka museum in Prague. Perhaps money-making without anxiety is being imported back into Europe. Perhaps we will all sleep easy.

The native mask in the hatbox on top of the beds places the installation: Kafka read and knew the history of penal colonies made by Europeans in non-European lands. He imagines them coming home. This is how he sees the 20th century before it happens. When it happens it is merely Kafkaesque, an icon of itself. The Kafkaesque: "The 'K' word has become an adjective today, not Kafkan but Kafkaesque. The 'esque' is not the aura of Kafka but the need to eliminate him by the critic's assimilation of emancipatory modernism into mass culture by refus-

ing to recognize the referential contexts of his work. It is the very loss of reality, the loss of referentials, that has now become the norm for which Kafka's tales speak of their traditional repressive power of secular authority over our gooseflesh."[1] Not Kafka, too much Kafka, not enough Kafka, is Kafkaesque.

The reversal of Europe and colony works through the transcendental, the absent God, the God-position. Their connection is not merely reciprocal, dialectical, so that one could be exchanged for another. The relation between colonizer and colonized is established through a supervening relation of each and both to the used-to-be transcendental ground to their presence-in-relation, the opening through which they co-presence. The constant relation between (a) theology and social criticism in Kafka between which some readers think they need to choose is rooted in the opening which grounds the reversal: both the absent God and the critique of violence. Where is the God-position in Zaslove's installation? The filled in walls, the stuff everywhere, too much to read, the 1960s concrete of fortress SFU pressing in from all sides. The God-position, infinitely far away, appears outside, but the feeling of enclosure, of being closed in, not able to get out, is the absent God-position. The x-rays that hang from the ceiling mirror Kafka's mechanical diagnosis of an inside produced by the excesses of an outside: the name of one's crime written on one's back. Look out the window to sunny Vancouver: it's not a crime any more. One just needs to adjust. Therapy is about being normal, Kafkaesque.

The reversal of the penal colony, violence without the unconscious, steers Kafka's gaze from Central Europe toward the happy skiers above Vancouver. Who needs Kafka? Those possessed by the Kafkaesque. Zaslove's lecture accompanying the opening, "On Some Motifs in Kafka," was structured around taking the listener from the work in

1 Jerry Zaslove, "In the Spirit of 'Odradek': Cultural Icons and Recognition of the Person in Kafka, Adorno, Benjamin, Hillis Miller … and Ivan Demjanjuk," *Journal of the Kafka Society of America*, 19 (1/2), June/December 1995, p. 63.

question, *In The Penal Colony*, back toward the experiential point from which Kafka could conceive and write the work. Several preliminary tasks therefore presented themselves: he had to undermine the pre-digested way in which Kafka and his works are now framed as Kafkaesque in order to allow a real confrontation with the work itself. He excavated the history of the penal colony until that time, and showed Kafka's awareness of it, in order to argue that the work is an anthropology of the present, of the emerging 20th century.

This is not history, at least not in the normal sense. It does not put Kafka "in the context of his time," but shows how Kafka's work becomes possible by tracing it back toward the point from which it could emerge. It is the emergence that is at issue not its prior conditions, and certainly not to reduce the emergence to its supposed conditions. It is a reading-back through history to encounter the emergence as an emergence, as new.[2] To the extent that the listener to the lecture, and viewer of the installation, is through this procedure confronted with the site from which Kafka's works could be written, s/he is able to experience 'originally' Kafka's work as an emanation of that site. This experience would allow a reading of the installation as also a return to that site and a commentary on it that, though influenced by Kafka, is nevertheless a commentary on the site rather than the text, ie. not on *In The Penal Colony* but on the anthropology of the 20th century. Thus, Vancouver is everywhere and nowhere in the installation, Simon Fraser University also. The 'method' of critical reading that Jerry calls 'radical contextualism' is at work here as "a theory of experience in regard to the way the novel [in this case the instal-

lation] 'phenomenalizes' the reader's engagement with his/her own life, but is historicized in terms of the novel's capacity to change how we think about our preconceptions and social conformist beliefs."[3] The Holocaust is everywhere and nowhere as well. After Kafka, it is even more urgent to return to Kafka, out of Kafkaesque normalization and back to the site from which Kafka wrote, to see the horrors around us as horrors, the penal colony in colours of institutional grey, the insurance man in his untroubled sleep.

2 It seems to me that this procedure is a schritt zuruck in Heidegger's sense, a Destruktion or a deconstruction, in the sense that these derive from Husserl's Rückgang and Abbau (unbuilding). A going-backward that Husserl noted could only take a spiral form of expression: going back and coming forward while retreating back to the site from which the 'institution' (in this case the work) began.

3 Jerry Zaslove, email communication to the author, 3/7/2001.

JERRY, ED, FRANK, FRANZ (& FRIENDS) AND I WALK INTO A BARRIER...

» ryan andrew murphy

It was the day that MJ's death would be the top news story.

Murphy rode the Skytrain to SFU, to see *The Insurance Man: Kafka in the Penal Colony* at the SFU Gallery, and to hear Zaslove talk about it.

M arrived late. The hall outside the gallery was noisy. The wide glass door scraped loudly across the floor and crashed shut as M closed it behind him. What kind of creature is M? Does he contemplate grace?

Z interrupted himself to greet M, who heaved a sigh of apology for his wretchedly cacophonous entrance. In his impulse to shrink and disappear, M was reminded of a story he once read about Franz Kafka: Having walked in on a friend who was sleeping, K told him, in a whisper, to "please, consider me a dream."

M believes that he read this in the book *Introducing Kafka* illustrated by Robert Crumb; but here, as in so many places, M's memory fails him (in truth, he read it in *Dostoyevsky, Kierkegaard, Nietzsche, and Kafka* by William Hubben)

The thoughtfulness, the deep consideration of others evident in the life and works of K, is one of the aspects of K that appeals to M, politically. M

sees it as analogous to the tendencies that Steve Collis has traced in the work(s) of Phyllis Webb. M is reminded of this because it is part of the social web—one thread of the tangled affections—that binds M's life to Z's.

M shook his head at the failure of his conscientious gesture of closing the door.

But the echoes of the hallway dissolved, and Z resumed his sentence where M's intrusion had hyphenated it. Z led the group on a tour of the exhibition (How unlike the Officer leads the Explorer?—How very unlike the machine itself? —Z led the group, as an illumination in the shadow of the horror, not as an extension of it).

M snapped dozens of photos. In the months since, M has beheld those fragments and wondered: What happened that afternoon? While M remembers vividly (more so, with the assistance of digital photos) images of the environment that Z created, the sounds, including most of the words, have since been corrupted.

What remains is visual and tactile: M remembers Ed Broadbent sitting in the small chair by the equally small desk beside one of the walls dividing the space, and M remembers the feeling of shaking EB's hand after exchanging remarks about, Z and his art, teaching, and friendship. EB thanked M for starting the conversation.

M remembers years earlier, when he first encountered *In The Penal Colony*, as an adolescent reading the liner notes to Frank Zappa's "We're Only In It For The Money". But M didn't read the story while listening to FZ. Despite FZ's instructions, M read it in the library. What does Z do? In classrooms, in galleries, on sidewalks, he creates a space of solidarity. By building a "machine" for (re-) immersing visitors in the horror, beauty, and absurdity of "another" place and time—and another (reflection of) reality within that—and by asserting some of its particularities (this chair, that wall), Z builds a utopic crossroads where parts of the "now" and the (global) "here"

that are usually kept remote (as current headlines about Canadian military complicity in the torture of Afghan prisoners push these events far away and into the past) can be witnessed, mourned, celebrated, or condemned. The "Condemned Man" can be heard. Can CM speak or only scream? We have to decide.

We are invited, like the Explorer, and we are treated like guests. Introductions are made. There is a bucket on the floor, filled with absorbent cotton, for the blood to flow into. Z is a good host, ghost.

Jan Masaryk 1917. Diplomat, Politician.
Langhans Portrait Gallery.
Reproduced with Permission of
Langhans Portrait Gallery

KAFKA, TRUTH, AND AN ART-ARCHIVE PARADOX

» MICHAEL BOURKE

In his essay collection *The Curtain*, Kundera defends Flaubert's fictional work against the expansionist aims of the archivist: "the work, *l'oeuvre*, is not simply everything a novelist writes—notebooks, diaries, articles. It is the end result of long labor on an aesthetic project" (96). Kundera's censure would seem to compound the bad faith of a Kafka scholarship which continues to discover and to organise his unauthorised oeuvre, and by extension the bad faith of Kafka criticism which takes this oeuvre, and much else, as the proper context for recovering the meaning of his stories and novels. If Kundera is right, should we isolate Kafka's fiction from the expanding work of the archivists? And should we, perhaps invoking the modernist credo *l'art pour l'art*, protect it as a pure aesthetic object from all extra-aesthetic reality which doesn't find an explicit home in the work itself? In the brief discussion below I accept Kundera's modernist censure as a constraining heuristic and suggest a conceptual distinction which nonetheless will allow us in good conscience to expand the significance of Kafka's fiction.

The distinction: Non-fictional works—essays, notes, letters, documents of various kinds—contain many truth claims, declarative sentences which are either true or false; they have, as philosophers say, a propositional content. Fictional works on the other hand make no truth claims; they contain no statements which are literally true, no propositions. This distinction, innocuously, upholds the well-known distinction between showing and telling, between using language indirectly to suggest something to the reader (metaphor is a paradigm of this use of language) and using language explicitly to say something (statements are the paradigm here). But the no-truth-in-fiction distinction is far more radical, and far from obvious. Consider the objection that virtually every fictional work ever written positively brims with declarative sentences, sentences which seem explicitly to say something, to make claims about reality which are either true or false.

This apparently compelling objection trades on a subtle equivocation, namely that sentences per se are the bearers of meaning, as opposed to the entire structure of a language, and the relationship of that language to reality. The objection thus simply assumes the view generally rejected by philosophers of language and linguists that sentences in isolation from a language convey meaning. Without this equivocation, or undefended assumption, it is difficult to imagine how any reformulation of the objection could succeed, even this refined version of the objection: that many sentences in fictional works are indistinguishable from (look the same as) sentences which can be uttered outside the work of fiction. It is straightforwardly true that many sentences in a fictional work could be extracted and, without changing their linguistic appearance, recast as statements, non-mimetic, literal claims about reality; yet it doesn't follow that within the context of the fictional work the same sentences literally say, i.e. explicitly state, anything about the non-fictional world outside the text, about reality. Indeed were they to do so, as readers we would no longer find ourselves reading a purely fictional work.

Perhaps that's not a problem if we decide to reject the purist art-for-art credo, and not let it extend into

semantic theory. There is a trivial sense in which fictional and non-fictional contexts do overlap, a sense in which they allow us to use language interchangeably between these contexts. One of the points of the no-truth-in-fiction distinction, however, is to become clear about the linguistic role, the mimetic role, of any utterance or piece of language in a story or novel and to distinguish this use of language from the way a similar utterance works when used to state facts about the world. A reader might of course still talk about narrative facts as though they have a life outside a novel or story. She might, for example, wonder whether anyone in early 20th-century Prague wore a nightshirt (The Trial), or whether there ever existed a penal colony which centred its judicial process on an ingenious sentence-inscribing torture machine (In the Penal Colony). But these hypothetical claims, whether true or false, function outside the fictional work, in a language which is capable of expressing propositions, statements which are literally either true or false about reality. Fictional language by contrast has a radically different function, one which we should hesitate to weaken, even if the temptation to do so were coherent.

The temptation to see language working mimetically within a work of fiction as somehow propositional, as simultaneously expressing truths outside the work, standing as it were with one leg placed in the real world, entails insoluble problems for our very understanding of the connection between truth and language. A problem nearer to literary critical concerns is that we would undermine the rich economy of meaning of the fictional work, and as it were create a colony within the work to which all mimetic truths that don't correspond to real-world (non-narrative) facts would be consigned. For example, nightshirts, which after all were once common enough in the real world, would enjoy a special dispensation that would allow them the freedom to move in and out of the work, or to figure in claims that refer simultaneously within and outside the work, whereas a purely imaginal torture machine would remain fixed inside the work. A practical problem occurs with this arrangement. Even if it could coherently be made, it would substitute a rather trite relationship between fictional and non-fictional facts for the incommensurate and open-ended mimetic relationship which exists between fictional language and the real world, a relationship not of factual correspondence but of suggestive parallels which operate outside the constraints of logic, truth, and conventional linguistic meaning.

The benefits of a language which operates outside these constraints: In a real-world/natural language, statements are fixed, so that a sentence expressing a statement has a univocal meaning and expresses a single truth. Were the fictional language in Kafka's penal colony story to operate under a similar regime, all narrative talk describing the torture machine would roughly be confined to a description of a mechanical device which once upon a time performed a rather pointless task and now no longer adequately works. Even if the description were fleshed out, we would be left with an imperceptive, unimaginative, perfectly literal reading, the kind of reading that the officer might offer were he to materialise as Kafka's most unflinchingly literal reader. Under a more flexible regime, which sees fictional language as inherently indeterminate and (therefore) non-propositional, the seemingly literal narrative description can be maintained; it doesn't become literally false the way we're sometimes told every metaphor does once we fasten onto its real meaning. For there is no question of truth and therefore no question of the narrative description being false; nor of it embodying a special meaning which it conveys to us and which can be formulated as the truth that the fiction is really expressing. Instead we have as many interpretations, ascriptions of non-literal meaning, as the particular words and sentences of the story can productively yield.

The Insurance Man installation tacitly observes the no-truth-in-fiction distinction, by playfully turn-

ing a diverse assortment of archival and other materials into an open-ended aesthetic response to Kafka's penal colony story, and thus avoids simply collapsing the wall between art and reality. In this way, the installation suggests a tension in the issue that Kundera raises concerning the autonomy of aesthetic works. It resists treating the story and these materials as a common work—as Kundera would have it "an enormous common grave" in which the novelist is buried under the weight of the totalising archival oeuvre—even while displaying the materials as part of the potential context of the story, as informing prospective interpretations of the story. In his curatorial statement, Jerry Zaslove hints at this tension when he describes the installation as bringing ordinary objects and interests from Kafka's life into contact with the story, through "a mise en scene [which] allows us to see the execution as an everyday affair" (4-5). Were we to take Kundera's comment as a prescription to wean ourselves from all such contact, we would absorb something of the reductive spirit of the aforesaid hypothetical officer's literal, non-mimetic reading. Not only would we cordon this text and others off from the prosaic actuality of Kafka's own interests, but, more importantly from the standpoint of the modernist aesthetics which Kundera supports, from the artistic virtuosity with which his stories and novels transform these interests into an aesthetic product, modestly in the case of a nightshirt turned into a minor variation of the larger joke through which the narrative of The Trial unfolds, and with spellbinding dexterity and scope in the case of the central mimetic device of the penal colony story, a literally unimaginable execution machine which artfully recovers discourses, materials, and events, which literally remain outside the story.

Frantisek Zaver Salda 1924, Literary Critic, Langhans Portrait Gallery. Reproduced with permission Langhans Portrait Gallery.

Jaroslav Virchlicky 1911; poet, translator, dramatist, critic.
Langhans Portrait Gallery. With Permission of Langhans
portrait gallery

Portrait of Nathalie, 1905; Princess of Montenegro. Langhans
Portrait Gallery. With Permission of Langhans portrait
gallery. Photographed in the Langhans studio at Vodickova
37, Prague, from 1880 to 1948. Reproductions in Collection of
Jerry Zaslove.

THE YELLOW ROOM IN THE PENAL COLONY

» KATHI DIAMANT

I have recommended *In the Penal Colony* to young men and teenagers as a point of departure and discovery of Kafka. But to be honest, I never liked the story; it was too cold, cruel and violent, and I didn't see the point of it. That has changed, thanks to *The Insurance Man: Kafka in the Penal Colony* at Simon Fraser University's Art Gallery. I stand enlightened, better versed in the historical, cultural, and visceral context, the cauldron that produced the creative environment for this peculiar story. Created by SFU Professor Emeritus Jerry Zaslove with help from Art Gallery Director and Curator Bill Jeffries, their engaging installation, at times playful and whimsical, and then starkly serious, revealed how Kafka's life experiences, the materials he read, the events he witnessed, and unique views of the world he inhabited, inspired the creation of *In the Penal Colony*.

It is essential to understand who Franz Kafka was as a human being in order to understand what he wrote. *The Insurance Man: Kafka in the Penal Colony* took me by the hand through a multi-dimensional artistic, literary, autobiographical and decidedly theatrical art installation, a metaphorical slice of Kafka's life. Zaslove masterfully combined a rich lifetime's gathering of materials, photographs, related historical and archival documents, and interspersed the story text with Kafka's diaries and letters to the effect that his world and his literary creation intersect, all bathed in a warm yellow glow.

As a biographer, I know the joy of finding documents, objects, images that my subjects have seen, touched, felt. Zaslove and Jeffries' collaboration recreated that sense of exploration. Finding one of Dora's postcards in a cabinet drawer, I was again thrilled by the discovery and its connectedness to Kafka and Dora. The icing on the cake was the audio presentation of Kafka's story-fable, available on earphones, offering the opportunity to listen to it immersed and surrounded by context.

Kafka died in 1924, virtually unknown outside the literary circles in Prague, Vienna and Berlin. In his meteoric posthumous rise to literary sainthood, Kafka became the most influential, yet profoundly misunderstood figures of our time. Zaslove said he wants to break the spell of the mystifications around Kafka as a writer, and it's a noble, a necessary goal. For the misunderstandings surrounding Kafka are pervasive. Despite the designation as a father of the modern novel, dozens of biographies, and tens of thousands of books of critical analysis, most people remain unfamiliar with him. The prevailing image of Kafka as morose, alienated and lonely, stands in stark contrast to the extraordinary man described by those who knew and loved him as amusing and kind, usually cheerful, a born playmate, always ready for a joke.

Kafka's powerful literary themes, which earned their own adjective, have overshadowed his life, and he has been reduced to a caricature, a composite of his autobiographical but fictional protagonists. Complicating the confusion, scholars and academics over the past 75 years have formulated countless plausible theories, written dissertations and published essays about Kafka's literary intentions and meaning, building their cases on everything from schizophrenia to homosexuality. Even the Kafka Museum in Prague seems to further that dark impression. The atmospheric museum of narrow rooms, low ceilings and dim light reinforces the supposed gloomy life of Kafka.

In contrast, in the exhibit at SFU Art Gallery,

lemon colored light illuminated the morbid and inhuman realities that Kafka wanted to resolve.

The light at the gallery entrance and throughout the exhibit was warm and welcoming. A palm tree in a corner placed us in the South Seas, where penal colonies existed during Kafka's lifetime. Remember Devil's Island? Drawn in by the theatrical trunk and costumes, the photographs of Kafka's contemporaries, the writing on the walls, I was led around the room, identifying the ingredients which led to Kafka's literary endeavor. According to Kafka's last love, Dora Diamant, understanding the motivation for Kafka's writing was at the core of understanding Kafka. The point of his writings, it seemed to her, was that he "resolved... conflict through art, the best method he possessed for bringing order in to the world."[1]

If the 20th century was riddled with what Max Brod, Kafka's biographer and literary executor called "the inevitable distortion of his image"[2] the 21st century is being kinder, and more accurate to the understanding of the man whose "scribblings" have been absorbed by nearly every culture and have inspired artists and writers as varied as Jorge Luis Borges, Joyce Carol Oates, William Burroughs, Susan Sontag, Phillip Roth, Haruki Murakami, Jose Saramago, Gabriel Garcia Marquez and Zadie Smith.

In the second edition of his biography of Kafka, Brod commented on the acrimonious academic debate surrounding Kafka's work. "One can hardly survey the gigantic essay literature that is concerned with Kafka," which "contains ... very many absurdities and contradictions.... Only the externals of Kafka's methods have been imitated or analyzed, but not his essential endeavor."[3] By producing an artistic environment that exposes Kafka's essential endeavor, the desire to resolve horror with art, Jerry Zaslove and Bill Jeffries have taken a significant step in academic rectification of "the inevitable distortions." For this Kafka students and scholars everywhere should be grateful.

1 Robert, Marthe. "Notes inedites de Dora Dymant sur Kafka." *Evidences* (Paris) 28 (November 1952).Translation by Anthony Rudolf in "Kafka and The Doll." *Jewish Chronicle Literary Supplement* (London), June 15, 1984, vii.

2 Brod, Max. Franz Kafka: A biography. New York: Schocken, 1963, 213-214

3 Ibid.

TRANCE ELATION

» MICHAEL BARNHOLDEN

Wunsch, Indianer zu werden
Wenn man doch ein Indianer wäre, gleich bereit,
und auf dem rennenden Pferde, schief in der
Luft, immer wieder kurz erzitterte über dem
zitternden Boden, bis man die Sporen ließ, denn
es gab keine Sporen, bis man die Zügel wegwarf,
denn es gab keine Zügel, und kaum das Land
vor sich als glatt gemähte Heide sah, schon ohne
Pferdehals und Pferdekopf.
Franz Kafka

The Wish to Be a Red Indian
If one were only an Indian, instantly alert, and on
a racing horse, leaning against the wind, kept on
quivering jerkily over the quivering ground, until
one shed one's spurs, for there needed no spurs,
threw away the reins, for their needed no reins,
and hardly saw that the land before one was
smoothly shorn heath when horse's neck and head
would be already gone.
Trans. by Willa and Edwin Muir

"OH TO BE a red Indian, instantly prepared, and
astride one's galloping mount, leaning into wind,
to skim with each fleeting quivering touch over
the quivering ground, till one shed the spurs for
there where no spurs, till one flung off the reins,
for there where no reins and could barely see the
land unfurl as a smooth-shorn heath before one,
now that the horse's neck and the horse's head
were gone."
Translator unknown

1. IF YOU WERE only an Indian, in an instant, alert, on a racing horse, leaning into the wind, jerking over the uneven ground, until you shed your spurs, no need for spurs, until you throw away your reins, no need for reins, and you hardly saw that the land before you was smoothly cropped prairie when your horse's neck and head would already be gone.

2. IF, ONLY, instantly an Indian, alert, racing horse, leaning wind, jerking ground, shed your spurs, no need for spurs, drop your reins, no need for reins, you hardly saw that the land before you was smoothly cropped prairie, your horse's neck and head already gone.

3. THE INDIAN IS the wish, the dream the fantasy, but the reality is the desire to live outside of capitalism, in a landscape free from the commodification of property.

Land, the ground we walk upon, wind, the air we breathe, outside yet inside the world as we have come to know it.

Fetish wear of consumer culture, stop and go, there and not there, presence and absence, the ambiguity, the ambivalence with which we participate.

See, there and then when, language is a dream, image is a hard line that ends at the edge where you looked out a window and what saw?

Hunter domesticated gatherer the big dog ate my homework and took me out for a power ride the mind body separation: I think therefore I am confused.

As if a horse is anything more than an expression of the eat it raw uncooked serial monogamous impulse dressed in leather from hoof to horn.

Flag thee gelding down, resuscitate the rose, cross the border, nice outfit senior, walk away singing, close the gap and hunker down in front of the blazing buffalo chips for a can of creamed corn.

Red he said she said but not right here not right now, is stronger than wine, cut my throat Cassidy, make me cry a river of blood.

I want out but I also want in.

ANT FARM

» LEE BACCHUS

About twenty-five years ago, shortly after I'd begun a career as a feature writer for the *Vancouver Sun*, a quasi-Kafkan character visited the newspaper office. Waiting in the reception area was a loquacious young salesman named Dave, and within the space of few words it was clear Dave was not long out of Junior Achievement or simply exuding his own fevered entrepreneurial imagination. With breathless enthusiasm he launched into his pitch for—ta-da!—Uncle Milton's Ant Farms. I should do a feature on them, Dave suggested, as he pulled one from his large briefcase.

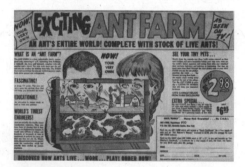

With an ache of nostalgia I remembered these from the tiny, tacky display ads on the inside back cover of my childhood comic books, alongside ads for X-Ray glasses, Charles Atlas muscle builders, sea monkeys and buckets full of plastic toy soldiers. The ant farm was a window on a world where tunneling Harvester Ants (mail ordered by Uncle Milton) would create a society before your very eyes. As a kid

I was entranced by them, lusted after them, but my parents feared runaway infestation and I never did contact Uncle Milton.

But how I loved them!

It didn't take a genius to realize Dave, who saw himself as an evangelist for an ant farm revival, was the human equivalent of the hurried ants in his own plastic farms or perhaps a version of the darkly comic Explorer in Kafka's penal colony or the obsessive compulsive creature in *The Burrow*.

So what does this wandering preamble have to do with this gallery installation? In many ways some of the artifacts in Jerry Zaslove's complex and beautiful exhibit—*The Insurance Man: Kafka in the Penal Colony*—reminded me of the ant farm I had desperately pined for as a kid. It was a tight social microcosm that would replace in fantasy the alienating suburban world I inhabited. And I would be in control. Of course, the ant farm was and is at best kitsch. Zaslove's assemblage transcends kitsch as did the many objects and emblems Kafka drew on to breathe life into his writing. Kafka's and Zaslove's materialism is founded on what I understand as the "transitional object." Those things that hover between one world and the next—between childhood and adulthood, between consciousness and dream, between memory and history, and between the self and the world.

These transitional objects—like the mattress that can serve as both marriage bed and death bed—can be both beautiful and terrifying. But above all we create and embrace these objects because they speak to us about our precarious condition as human beings in the grip of modernism and because they, perhaps only temporarily, loosen its hold.

Sometimes they can even promise a bridge to a new world.

Zaslove's engaging and compelling "natural history of a self" as I called it, leads the way, in and out of the transitional object—a sketch, a strata of mattresses, a doll, a book, a photograph, image ruins from Kafka's Prague and Zaslove's North America—toward the humbling understanding that Kafka's meaning somehow does not reside in any one dimensional and orderly interpretation but is suspended in an art that must be understood contextually, complexly and deeply through our own relationship with the phenomenal (sensate) world. Thus, the transitional object, where this "mindfulness toward reality" as Zaslove has termed it, is crystallized.

In other words, this indescribable (as it must be) collection of deceptively eclectic and beautiful relics of the commonplace and not-so-commonplace comprises the kind of "splinter in the eye" that Theodore Adorno said works as a magnifying glass that allows us to "see" rather than merely look. This of course was Kafka's monumental task as well, and here Zaslove has accomplished what Kafka himself had done repeatedly in formulating his stories — assembling the splintered yet cherished remains of history, dream, and memory to construct a work of art (but more importantly an experience!) that is both an homage to Kafka and a way through the labyrinthine veins and arteries of creatures who to this day are subjected to the "apparatus" and who seek relief and liberation from their relentless burrowing in the colony.

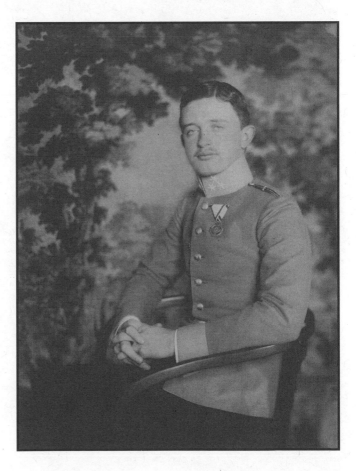

Karel I, 1912 Last Emperor of Austria-Hungary 1912. Reproduced with permission. of Langhans Portrait Gallery

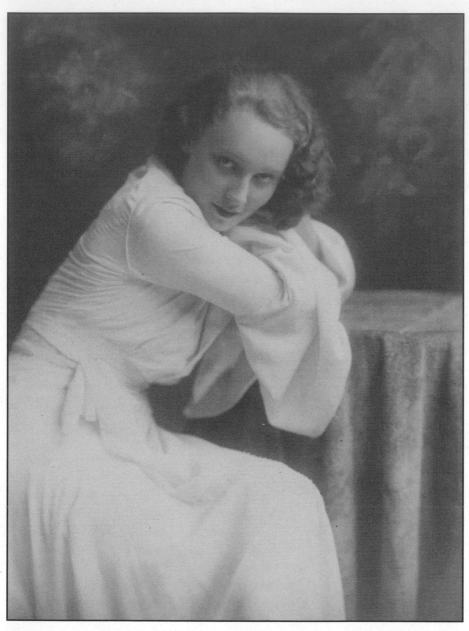

Lida Baararova 1932; film actress. Langhans Portrait Gallery With Permission of Langhans Portrait Gallery

CAGES, WINDOWS, SHADOWS

JOURNAL NOTES FROM OTHER EXPLORATIONS IN THE PENAL COLONY

» TOM MORRIS

» **GUANTÁNAMO. FEBRUARY 2007**
"The Insurance Man" installation's wire mesh and grated doorway, cage-like, bolted shut. Shutters pulled down over locked windows. Keep in, keep out. The familiarity of something seen in any Vancouver, Phnom Penh or Nairobi shop street.

What would be understood of the inner life of such streets, imagined in some uncertain future as layers of earthy detritus? Shards of private property, of mine, me, them? Signs of powerlessness, vulnerability, fear, anger, repressed anger? Rooms of unintelligible documents in a commonplace tongue. Remains of walls, locks, things hidden, surveillance, guards, enemies? (Always, apparently, the need for and availability of enemies) Evidence of pain, crimes, calamities?

Hardly a blink and I see Guantánamo prison. Journal notes: "The wire mesh gates and razor wire walls, padlocks and cages, orange-suited animal-prisoners dragged by, neck under the boots of, robotic guards; one corner of a sprawling cage transfigured towards normalcy as unsavoury but necessary (to use today's dizzying jargon), a thing designed to keep us secure, safe, free by housing rendered enemy aliens—'our enemies'—brought to it across a now globalized national security gulag of kidnappings, entrapments, black holes, secret flights, redacted documents (where 'editing' becomes the disappearing of evidence), a place where crimes of state are aberrations, the work of a few bad apples ... all the while hooding the rest of us in guilt for seeming to speak against our own safety, for not supporting our defenders, for not standing up for civilized values."

"My anger at the inflicted torments, at our powerlessness, perhaps even, after all these years, at my stubborn ineptness—because of some irrepressible hope?—at taking advantage of the foresight that experience keeps offering. I hadn't imagined, these past six or so years, the ease with which circumstances could be created in which due process could again be so openly disregarded, and where torture—its necessity and the earnest quibbles over its meaning—could so completely become part of the everyday."

» **TUOL SLENG MUSEUM, PHNOM PENH, CAMBODIA. OCTOBER 2003**
Once a suburban school called Tuol Svay Prey; then a Khmer Rouge torture and death prison (S-21) imagined and refined by one-time teachers, some imprisoned and tortured by the French; now the Tuol Sleng Museum of Genocidal Crimes.

Tuol Svay Prey's teachers would have expected unquestioning respect, the memorization of rules. That was just how things were. Later, S-21's commandant, one of many ex-teacher leaders in the Khmer Rouge, organized the meticulous documenting of new prisoners ("called to study," "called for consultation") who, under torture and before they are murdered, would have to invent confessions to crimes only their keepers knew.

Journal notes: "First glances. A playground, the remains of a swing set. The school buildings, window after window, door after door, the shaded verandas running along each floor, like so many colonial schools, hospitals and asylums in the tropics.

"Walking further, closer. Peeling paint, scratches on the walls, stained drain holes, burn marks, barred windows, razor wire. Classrooms divided into cells, bare metal cots, some with manacles, some with small photos of chained bodies ... I remember reading that screams could be heard a half mile away, about the 'mayhem' that breached every demand for 'correct procedures.' Nausea. A window. I want the comforting solidity of that shaded veranda.

"Room after room of small mugshot photos (like any passport, passbook, licence or identity card) of nameless prisoners. I move closer. I have to see one person at a time. That angry frown. Eyes and cheeks and lips that suggest such gentleness. Startled eyes. Expressive blankness. Puzzlement. The staring eyes, many directly into the lens, into me, crossing a line that Khmer Rouge directives said must never even be imagined can be crossed.

"Then I'm in front of several images enlarged to life-size. The eyes of a baffled girl look into the lens, into me, I to her. Then eerily she's behind bars that darken, then fade. Above her a sunlit window, a palm branch, then a soft arc of light, like a swing, that I imagine could lift her into that bright open space. Another image: a mother, overwhelmed sadness in her eyes, a number around her neck, holding a sleeping infant, and again over her shoulder a sunlit window, a half open shutter, and another small triangle of light with its fragment of shaded veranda over one eye, as if while obeying the order to look into the lens she can also see (or is longing to see) the smallest of bright openings towards life outside this horror.

"All this in the small moment before I notice the tricks of reflections coming off the plexiglass-covered photos. But in that moment I still remember the shock of seeing these ghostly presences. The barred windows unseen in the official photos but now as if insisted upon by the future-seeing eyes of the dead. And then the reassuring ordinariness of that sunlight, the palms, things I can name, a building's edge,

as if I was seeing things that would undo that purely bureaucratized image of the already condemned. I even imagined that it was something they, the dead, had contrived to make happen.

"Another photo gallery, hallway, a window ... where they suddenly appeared through a frame crisscrossed by razor wire. Three boys, one wearing an American flag t-shirt, playing on the remains of the school's swing set, one hanging by his hands, stretched out and swinging ... then someone, something awful there, hanging ... then the boy again, he's back-flipped onto the ground, reassembling himself after passing through the razor wire ... and I look and keep looking, amazed that children are still possible, that play is still possible, that playing here is possible.

"Walking out through the walled gate of S-21. The tuk-tuks and motorbikes still sputtering up and down Monivong Boulevard. A rooster crowing down some alleyway. Mr Tha, who had driven us there on his tuk-tuk, having a smoke and chatting it up with another driver across the street, sensibly under a shade tree. The shock of all this unreal ordinariness, and then of asking Mr Tha how he had been spending his time, remarking on the heat, and being surprised that words were possible and seemed to work. Then driving away, watching Mr Tha's back, and wanting to ask, if language had allowed, what he knew about S-21, if by chance he had been inside, perhaps even (given his age, not a far-fetched question) been one of its many adolescent keepers."

» **SHADOWS AND BONES. OTTAWA.**
NOVEMBER 2009

Remembering other walks. The crowded, preoccupied bustle of Kuala Lumpur sidewalks after visiting a family preparing for the funeral of their father, beaten to death by the police in what is a pattern of beatings the city's police carry out with impunity. Or the country trails up the valley near where I live outside Ottawa: the surprise of discovering one day

that I was walking through a 1940s internment camp ("Why were you arrested?" "I was Italian." "I was a labour leader."), perhaps walking over barbed wire and the mouldy files of those imprisoned without charge or trial. The sensation, as I once read was experienced by Dr. Juan Carlos Adrover in Argentina many years after the colonels' dictatorship (1976–83), of 'this whole country being a graveyard, and that we are all constantly walking on bones'.

Other people walking, this time experienced by the condemned, like Ana Maria Careaga—disappeared and tortured in the basement of a suburban Buenos Aires police station during the dictatorship—who remembers hearing/seeing signs of routine life through tiny openings in her cell, "on the floor the shadows of people passing by," the sounds of cars and buses, "life going on as usual" … a very particularized memory that also helps bring into view the many physicians, lawyers, journalists, electricians and cleaners (for example) in the colonels' employ, or those many members of the Argentine propertied classes who so easily embraced the colonels' rhetoric (now blaring again in our own ears) of criminal elements, terrorists, security, decency, civilization and the need for sacrifice, responsibility, toughness.

In a world where we are baited into identifying our ideals with the necessity of another's murder, into not seeing the glimpses of fellow life in the face of the condemned, into not wondering where our shadow might be falling—how then to recognize the lie in tomorrow's urgent, seductive calls to violence?

Perhaps all we still have is the threadbare advice of earlier refusers: the contingent powers of critical reflection, of single-bodied experience, of self-determination, of irrepressible hope, of not cooperating. And to ask where we are, where we've been, and where we're going as we dig through this installation, with its unreconciled, eerily familiar furnishings, the stuff of our continuing calamity.

» **SELECTED SOURCES**

On S-21, David Chandler's Voices from S-21: Terror and History in Pol Pot's Secret Prison (Silkworm, 2000). On Argentina, Marguerite Feitlowitz's A Lexicon of Terror (Oxford, 1998). "Earlier refusers" refers, among others, to critics like Alex Comfort, Paul Goodman, T.W. Adorno and Herbert Marcuse.

Tuol Sleng Museum display photo of Chan Kim Srung with her newborn child, based on the original S-21 prisoner mug shot taken May 14, 1978. Chan Kim Srung and her infant were reported "smashed" (murdered) soon after their detention. Photo: Tom Morris, 2003.

Tuol Sleng Museum display photo of an unidentified S-21 prisoner. Unlike the original mug shots, many of today's display images, set under plexiglass, include shifting light waves and images amplified and projected through the tropical sunlight outside. Photo: Tom Morris, 2003.

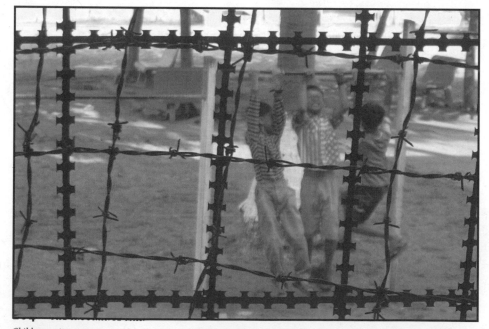

Children swing on gymnastic bars in the courtyard of the Tuol Sleng Museum. In the same courtyard, a similar frame from Tuol Svay Prey school was used by the Khmer Rouge to torture prisoners at S-21. Photo: Tom Morris, 2003.

LIVING THE MACHINE

» PEYMAN VAHABZADEH

I imagine the greatest challenge for the explorer is to unlearn, after his departure, what he unwillingly came to witness and experience through his outlandish voyage *In the Penal Colony*. The curious terminal crimographer[1] with its technological ambiguities and its utilitarian exactitude as well as the obscure, puzzling, ritualistic, and rationalistic mannerisms that govern the procedure of subjecting the body of the condemned to the machine—they all become a package of knowledge the explorer will carry with him beyond the penal colony.

As usual, one can do one of the two things with this uninvited knowledge. One, to absorb it uncritically, express and emanate it, and implement it elsewhere, perhaps closer to home, where one is no longer an explorer, so to speak, but an inhabitant, a native, a citizen. I imagine this needs great effort, requiring solving the problems of introducing and implementing an exotic procedural technique and rendering it, in due time, a part of the people's perception about how "justice" must be handled. But it can be done, and the garden variety totalitarian regimes of the twentieth century, McCarthyism, or Guantanamo Bay all attest to the plausibility of this project in various vernacular articulations of the machine.

Or two, to unlearn it: to unsee the violence, unload the memory, purge the horror, disconnect, speak to no one and write no entry in your travelogue about it. I am not sure if that can be done as easily as the first option can be achieved. After all, Kafka's

1 The apparatus.

explorer seems to have taken out of the penal colony the memory and knowledge of this punitive crimographer: we have the story.

When introduced to him, I met a Kafka who spoke Persian, through the (not-so-sophisticated) translations of his works by (now archetypical) Sadeq Hedayat (1903 Tehran–1951 Paris), whose surreal *The Blind Owl* received international recognition when André Breton called the French translation of the book a surrealist classic. Especially fond of Kafka's short stories, Hedayat translated and published "Before the Law", "Jackals and Arabs" and *Metamorphosis*. Persian Kafka, while strange, was not entirely mind-boggling. When I found Kafka in my father's personal library and read him in my early twenties, there was something of Kafka that I had already seen, lived, and unfortunately, internalized. I imagine the source of fascination of many western readers of Kafka is precisely their detachment from the conditions described in his fiction. That was not the case with me. I related to Kafka despite the fact that my leftist political commitments during post-revolutionary Iran constantly delayed taking this somber writer whose fiction, it was deemed, smacked of decadent, bourgeois disbelief in social change, into my heart.

Moreover, the prose of Persian Kafka did not have the aura of English Kafka (for me anyway), which I read only years later in my (self-)exile. The unlikely places and bizarre events of Kafka's fiction, even in those apparently mundane affairs in the Europe of his time such as the one narrated in "The Hunger Artist," did not raise my eyebrow, although I sincerely felt the impact. It was as though in my psyche or perhaps in my collective unconscious there was something familiar about Kafka's situations.

The story of my middle school (grades six to eight; 1972–1975) in East Tehran should not sound too unfamiliar in Canada, a country with the experience of residential schools for aboriginal persons. There, for three years, I was subjected to routine punishment

by our beloved vice-principal. The punishment was religiously carried out in a mostly controlled and calm fashion in one of two ways: strikes on the palm of the pupil's hand by a yard-long wooden stick, reserved for proper punishment, or rather impulsive slaps in the face, as a quick reminders specific to "petty-crimes." Any other form of punishment that might have been used by our committed vice-principal was noticeably irregular, outside the norm, and extremely rare. In fact, while I do know that there has been more than one such incident, the only one I recall clearly is the ritualistic punishment of an Armenian eighth-grader in the school yard and in front of the entire school population and it involved sheer beating of the poor soul by any means available, in savage but sacred fury of our dutiful vice-principal. And the reason for this exceptional punitive spectacle was, not surprisingly, the student's alleged "public" insulting of the Shah and the Royal Family in a way that my memory fails to recollect.

As for myself, I was deemed to be the "champion" of taking punishment, a title of reasonable status, by my fellow underclass pupils, those mostly meek subjects of school rules. I was the one who, for some strange reason, or perhaps due to sheer juvenile stubbornness, received numerous hard strikes, in front of the class, on the palms of my hands (for which you need to extend your arms out) at any occasion, without whining, weeping, begging, or showing any sign of remorse. Committed to restore order, our vice-principal was usually fair enough to announce the number of strikes (normally between 5 and 20) you would receive at the outset of his ritualistic punishment, so that you would have a quick second to make your decision (begging versus resisting) in advance. In the case of begging, he would graciously let you go after a few blows and some hard words. I wasn't exactly the exemplary student behaviour-wise, although I was academically more or less an "A" student, so I endured this for the entire three years of my middle school. Here is how Kafka became

vernacularized in my experience—vernacularized, that is, if he wasn't the vernacular story-teller of otherwise generalized forms of violence.

This is one incident through which I relate to Kafka, but unlike Kafka's instrument, the machine-like crimographer in my case, was not terminal, and that's why I am able to write these lines! Admittedly, it was not sophisticated either. It was a cyborg of sorts, half-machine, in its duty, and half-human, in his ability to forgive upon begging!

The cyborg lived in my very own neighbourhood (I occasionally ran into him years later at our local newsstand). Later on, I participated in the 1979 Revolution, post-revolutionary politics, the war with Iraq, and escaped from Iran to Turkey and excelled in my course in uninvited methods of punishment and violence, just to experience the machine again, in its various manifestations, realizing, in the end, that "guilt is always beyond doubt."

Like the explorer of *In the Penal Colony*, my knowledge of such violence was uninvited. The challenge, however, is to unlearn it.

Vancouver and Victoria, November 2009

THE FINAL ORBICULAR WORDS

» TOM MCGAULEY

Empire's afflatus a suffusion of arrogance and shame
hung over all like a falling Prague night
devoid of any other intention but profit salvation
and *aufhebung*'s culture of stultification
and rosemary arbors of a violently modified civility
Nawab bought 12 members of parliament
House committee reported early ills of monopoly
turning to aggressive territorial expansion
Nawab from which the English corruption *nabob*
islanders who managed the Company
who survived climate and multiple diseases
then returned to Motherland
richer than Nebudchanezar
Nabob in a later now independent colony a company
whose jam went over toast
of fathers and mothers on their way out into the grim
bisecting universes of intervening labor markets
Nawab remitted millions of pounds sterling owned
the committees of the House
nobbled a number of those in the Lords
 Capitalism began about this time
after Plessy and Clive
prodigies of wealth gelded the commons
Walpole acknowledges
to such monopolies were imputed
the late famine in Bengal and the loss
of three millions of the inhabitants
a tithe of these crimes was sufficient to inspire horror
 Three millions perished

A later colonial officer would not release the tented hoardings
of rice and grains at Fort St George
where I would recall your mother within and
against this ever present threatening
contingency of mass starvation
officer allowing only half the rations
half the calories bad Dasein Germans provided at Belsen
while tens of thousands
indeed hundreds of thousands
starved in the southern principalities of the
Presidency at the edge of empire different
but simultaneously similar or the same
in all theaters of settler colonialism
with or without the adhesiveness of the
mercantile plunderers and their cohort of explorers
and concentrationenlager administrators
prisoners disappear into death
pared or paired with scientific
Guantanamoid logicals
Despite shame empire writes its own
on the terrestrial body
What was guilt and embarrassment
to the broader populations at home
indignity at imperial-never-sated-hunger
shifted from the victors to the victims
they must be educated or eradicated
systems of profiting never endangered
Tea laced with sugar
commodities whisper in a children's garden of verse
have no visible paternity
but in the provinces
in the furthest reaches Death loses count
or blancmange of Motherland
re-scripts re-scriptures native base as he observed
about this province colonized
about the time of in another remove
the Great Rebellion of 1857
native people were in the way
their land was coveted and the settlers took it
eventually there were
approximately 1,500 small reserves slightly

more than a third of one percent of the land
Kafka hooks different bondages different apparatuses
different entanglements
different modes of mass demise
And cultural mono-cropping arcs control dominion
traced from cinnamon to cedar from jasmine to dogwood
Bloody bed averts torture's
prim aesthetic
blooded amputated
no resignation
but sings
era's tonsured etymon
Word wolf favours sonnet
Dinky protuberant milleflor
gestational cimcumflex
regularizes this
pointed at your deft
resistance
to beanstalk up
Spittle smeared
hooded gangsta sex
kitten thug
shirts and skins
threaten equilibrium's
mad jazzer
Commentary curls stories
complete
Marble me he says
but touch chest fire
old hymns rose red
recover ground-aires
of our meadow mountain mind
stories' nilotic apotheosis
No one equal
quadrant of all known totally
Then letters excruciating
escaping love
circumcised
small chest
thin-boned
over-thought

fingers penning
even in sleep
Overhead the all-seeing pharaoh eye of the sun the all
knowing patriarchal aperture
concurrent with voice over
neo-pragmatic tarnished Platonism
a depth of silence and wind rustling
two men speak two worlds intermingle in an event
a third awaits death
In several photos the apparatus
nears its own demise transformed to aliveness
throws itself into self-disintegration
Two men speak
one with the prominence of narration
pleads begs asserts
his time over his role superseded
A sum of metal and small bits of felt and cotton wool
with pedagogical intent a covert autonomy
spells the Father-name of authority
perfect paradigmatic irrational blind
without process language or appeal
And flesh becomes punished word
a moment an eternity awaiting its Foucault
but masterfully Kafka arrives
demotic drama ahead of his time
Prisoner vomiting who usually ate fish fed candies
interrupts execution soiling machine
thus not only lazy dog but agent of pollution
Plus the two nakedness'
one at the end of a bayonet
and the voluntary nakedness of the officer
who has lost the argument faces financial
and bureaucratic ruination
slippage down ladder of the colonies'
nomenklatura
The transfer of the sites of spectacle
from the space of public
execution
where now there is no one to watch
to the hall of official reportage the
Meeting where he knows his end is nigh

and his beloved justice-enlightenment
machine will be erased demoted removed from
enforcing colony's routines of law and order
Dialogue pseudo-empirical
officer as the declining
mode of punishment
seeks to make his case in the language of diplomacy
 the French of official culture
a parody of discourse and discipleship
 tracing the gap between regimes
And the radiance of enlightenment
official state-sanctioned savagery
a fictional annex set aside from
but close to the merriment of
horror the displacement of the comic
but a slight veneer of modernity's trajectory
towards rule and punish
within the cellular within the mass at the edge and in the
 heartland
Laughter finally at the prisoner bare-backed and
bare-bummed in a monological institution
human sacrifice consummation of the Law
thence the move to the next radiant illumination
Hiroshima.
Auschwitz.
Iraq.
Multiples of mass extrapolations
the continuum of incarceration injustice and insurgency
not to be tamed by clay or art
form militant silver soldiery
Here terra cotta fractured sestina
rendered transparency of subversion too
much melts to this *the despised* concrete
cuts the air of prophecy utters utterly
cashiered no eyes to the burning city
the scarcity the scarcity of means
and adjusted miserly ends
prohibiting larger structures the institutional dream
of its *ever forever* over which naked he gymnast
kouros bleeding tubercular K in the Prague window exercises
the endless procrastination of the final orbicular words

Alois Jirasek, 1920; Novelist and dramatist. With Permission of Langhans Portrait Gallery

KAFKA ON CAMPUS, SANITY UNDER SIEGE

» MARK JASKELA

I

Jerry Zaslove's installation at the Simon Fraser University Gallery, *The Insurance Man: Kafka in the Penal Colony*, embodies Zaslove's reflections on institutionalized barbarism and Franz Kafka's prose. Seeing space devoted to the tangible actualization of Kafka's *In the Penal Colony* evokes in me a tangled mass of responses that are at once personal, terrifying and, ultimately, hopeful.

The installation is an accumulation of images, objects and signs quoting passages from *In The Penal Colony*. The exhibition is the making literal and concrete the printed word. Although Zaslove is not a religious artist, there is a religious quality at work here. Jesus Christ is the word of God made flesh. Zaslove's installation is the words of Kafka made genteel chamber of horrors. As Zaslove puts it, "We reader-spectators are distant from the torment machine and yet are inside it...." The place of refuge from harried campus life becomes the site where we are ambushed into empathizing for the real-life victims from whose agonies Kafka distilled his fiction.

Through the continuity between the excesses of authoritarian colonialism and violence to the body, Zaslove presents a colportage array of mementos, souvenirs and text. He explains, "We see Kafka's texts on the walls inside our head where writing is". The incongruent assembly of items interwoven by Kafka's text beckons us to live Kafka's narrative. We are drawn in in much the same way effective prose or cinema can, to the deranged mind, become a central motif of perception and thought. Whereas I doubt it loomed large in Zaslove's intentions, this theme is where his installation addresses my deepest pain, my worst fears and my own experience before the law.

II

Comparable to the irony indwelling Kafka's penal colony occupying the art gallery of a modern university, deceptively civilized-looking surroundings mask the nature of the modern courtroom. Fine wood furnishings, spotless carpeting, flags and comfortable seating obfuscate the fact that this is an arena where profound violence routinely transpires. Men and women are deprived of their freedom for years, even lifetimes, life savings are wiped out, marriages torn asunder, families destroyed, reputations ruined and, in some places, people are still sent to their deaths. Occasionally, something approximating actual justice is dispensed. Twenty-eight years ago when in a state of sleep-deprived psychosis and in the wake of surrendering my life to Jesus Christ, I cracked up in the home of my then girlfriend, causing minor damage to her household. I was arrested and sent by court order to Colony Farm for a 30 day psychiatric evaluation to determine if I was competent to stand trial. Originally established in the 1940s as a 'veteran's unit', Colony Farm housed the beleaguered souls who lacked the requisite insensitivity to participate in wholesale butchery or had been brain damaged as a result of trying to. Eventually, Colony Farm became a hospital and prison for the criminally insane.

I was released after ten days of detention and treatment. Despite a rapid return to a normal, productive life and my by then ex-girlfriend's wishes to the contrary, Crown Counsel declared that they would seek to have me found not guilty by reason of insanity and sent to another psychiatric facility for a year. My lawyer assured me that if I copped a plea, I could instead go to a prison work camp for two years. For 29 months I reported weekly to a bail

office as Crown Counsel, without a witness hostile to me, dallied about setting a trial date.

Two days before my trial was to commence, with my re-incarceration a seeming certainty, my lawyer phoned to inform me that Crown Counsel had dropped the charges against me, that there would be no trial—as if I hadn't been through one already. I'd toured one of our province's own 'colonial' torture machines and had seen how its tentacles permeate the highest levels of bureaucratic society.

III

Zaslove's materialization of the textual is a metaphor for alchemy. It aligns his installation, in spite of itself, with a form of radical optimism by way of a symbolic manifestation of the miraculous. This is a non-stereotypical reading of Kafka. With *In the Penal Colony*, Kafka intimates the possibility of escape from conditions of senseless cruelty through the character of the explorer. Following Kafka, Zaslove has engineered a vicarious experience of a torture machine we are free to leave with the same ease with which we exit a metaphor. Central to the installation is, I think, the idea that even in the farthest reaches of secular despair, hope perseveres. Respective to the vestiges of the miraculous in the installation, I'm not suggesting that Zaslove is advocating a symbolic reading of Kafka. He isn't. Yet the process of transposing one form of codification into another, in this case the linguistic into the palpable, seemingly brings to Zaslove's mind and, subsequently, the associations he imparts to us, an aesthetic methodology rooted in the manipulation of text, objects and images that cumulatively take on symbolic significance. As we grope toward making sense of the installation in its bewildering totality, our thoughts may be drawn inexorably toward symbolic readings. The enduring power of the metaphorical that is endemic to all art insures that the aesthetic can never be removed entirely from the symbolic. Neither the installation nor the personal anecdote I have related here belong to a reader-response hermeneutic. Rather, in keeping with Walter Benjamin's maxim that there is no document of civilization that is not also a document of barbarism, both the installation and my appraisal of it are, at their roots, exegeses on the bureaucratized continuum between rationalism and the barbaric. Symbolically laden hermeneutics are, admittedly, a personal inclination of mine but in this instance, I hope, grounded in the bedrock of the following: "If we are out of our mind, it is for the sake of God; if we are in our right mind, it is for you. For Christ's love compels us, because we are convinced that one died for all, and therefore all died. And he died for all, that those who live should no longer live for themselves but for him who died for them and was raised again," (2 Corinthians 5:13-15).

PARADOX & PAROXYSMS

AN OPEN LETTER TO THE INSURANCE MAN: KAFKA IN THE PENAL COLONY

» carl peters

"When one has no character one has to apply a method."
- Jean-Baptiste Clamence

cu•rate
[Middle English curat, from Medieval Latin crtus, from Late Latin cra, spiritual charge, from Latin, care; see cure.]

to whom it may concern—
i wanted to say,
The Insurance Man: Kafka in the Penal Colony is a critical autobiography in which yu come to be a companion to Kafka—a true companionship. One is soon overwhelmed by th awesum intimacy uv th show. Now, when something is this personal it cannot fail but be a prophecy uv sorts (or eulogy—there is this melancholy aspect), which, precisely, is what th installation is: a depiction; an arrangement; a parable; an archive. What I read in th show does not exist, no longer exists. I know uv no other way to respond than to write what I am writing, if I can do it, as a parable, an aphorism; more than anything—a fragment; an attempt to imitate this formal aspect; which seems closest to truth somehow, whatever that is (does it matter?), only becoz it is closest to (most intimate with) experience—my own; i kept imagining yu

rooting thru boxes and archives; th first book yu showed from Klaus Mann that was in th trunk—I spent a moment there, I was moved your gesture here, placing it there—I got th mathematics uv that; th archive itself is an imaginary space, a space between what was and what is, utopic in that sense, which is intimate with th art uv th lecture, which is what yu do; which is what I've always wanted to do. To profess is to prophesize you see. Th evangelical aspect is clear becoz it is sacred (to us). That is not arrogance. It's so simple, really; it's simply our profession. And it has more to do with a damaged self (Adorno) in search uv itself still. This was you unpacking your library. This is you unpacking your suitcase. Broadbent there,[1] I wanted to introduce myself and shake his hand, but I'm shy.

I am drawn to K's aphorisms most uv all; objects—beds & books, pictures & masks—maps—direct us to walls with aphorisms and quotations printed on them; these force us back to objects; th play uv consciousness; th archival imagination at work; there are walls everywhere; I kept bumping into those. What happens when yu take th *book* out uv th book? What happens to th text when th page becomes a screen on a wall? How is this different,

1 Ed Broadbent—well known political figure.

really, from coming to it in a book? It takes a great deal more courage, for one, to put it there on th wall for all to see if they look. One goes missing in a book. The reconstruction of the view looking out from an office window to Vancouver induces meditation; placed on a conference table inside this office is a will—your will, th curator uv this installation, a document which is sealed, hidden away, until—well, th will is always after th fact. Its presence confirms my absence. And i needed (aftr bearing witness to that scene) to look for, once again, Klaus Mann. I needed to see it, th book, to know it—to see it there (this book), and to know (just perhaps?) that th missing can be *found*. Your will and this book are th 2 most poignant, most profound, texts in th show. Th will itself is a paradoxical text. It represents presence before absence. I asked yu once about survival, your survival, my own in th face uv things: how did yu survive; or, more precisely, how do yu "survive survival?"—"the survival that I never survived" (Kaddish 112); I know th question's been with yu like a poltergeist; I need to know: how did yu do it? Times have changed; and the installation makes it clear to me that what was poetics, open form, is now pedagogical dictatorship; "university *with* condition"—to paraphrase Derrida; times have changed; indeed, time has changed. I'm sending yu my question again. What is left? To answer my own question: a procedure. One cant stress enough th fact that *The Insurance Man: Kafka in the Penal Colony* is shown in an art galley in a university implicating us all who write on it —and within it.

The Insurance Man: Kafka in the Penal Colony opened my eyes and conjured up inside me memories uv my first exhibition—my MFA exhibition and show was ahead uv its time, now I know, becoz that show was also a "book" up on th wall. What I am trying to say is that i have searched and searched and *searched* for work like this, and i have always felt a guilt in me—that i dont paint th way others paint or draw. But what i am doing, i think, is what yu have

accomplisht with this show. Works uv art communicate and then they dont. They need us to explain them. Somehow th installation depicts what writing cannot; how many viewers—'volunteers'—realized that this room they entered, this installation they read was not an exit, but rather an entrance deeper and deeper into th maze, th ant-hill,(wherein, in fact, one is always in desperate need uv insurance)? I know exactly what *The Insurance Man* is: tenured. That is precisely what makes him repugnant, amoral, a desperate character, "aesthetic." Th colony as procedure without person.

Here is the paradox: insurance creates necessity. Roland Barthes' comments concerning a lover's discourse defines precisely what th *Insurance Man* represents: its ethical centre is to be found in th archival imagination uv th reader as witness; observation as protest:

> The necessity for this [installation] is to be found in the following consideration: that the lover's discourse is today of an extreme solitude. This discourse is spoken, perhaps, by thousands of subjects (who knows?), but warranted by no one; it is completely forsaken by the surrounding languages: ignored, disparaged, or derided by them, severed not only from authority but also from the mechanisms of authority (sciences, techniques, arts).Once a
>
> discourse is thus driven by its own momentum into the backwater of the 'unreal,' exiled from all gregarity, it has no recourse but to become the site, however exiguous, of an affirmation. That affirmation is, in short, the subject of the [installation] which begins here . . .

This is the opposite uv cages going in search uv birds. This is the aforementioned author's ideal uv a *writing degree zero*.

In the installation, a number of beds, placed one on top of the other, reference this extreme soli-

tude—these are deathbeds. (One thinks uv Rauschenberg, Kienholz and Segal.)The viewer suddenly finds herself in attendance at a wake. Remember th will?

I choose to read *The Insurance Man: Kafka in the Penal Colony* as a kind uv lover's discourse, a discourse outside the rhetoric uv discourse; an aesthetic discourse. "Aesthetic choice is a highly individual matter," writes Joseph Brodsky, "and aesthetic experience is always a private one. Every new aesthetic reality makes one's experience even more private; and this kind of privacy," he concludes, "can in itself turn out to be, if not as guarantee, then a form of defense against enslavement" (260). *Kafka in the Penal Colony* may point to a once Utopic space, but that is all it can do. Utopic space is archival space "severed from authority but also from the mechanisms of authority"; for th *Insurance Man* discourse is a procedure—that's th problem; "A cage goes in search of a bird." Dare I *look* beyond my discourse? My colleague the insurance peddler? Language is th apparatus, and this is precisely what the exhibition, *The Insurance Man: Kafka in the Penal Colony*, tells me. The curator uv this show, like all great lovers, wears his reading on his sleev

Austrian Recruits. Photograph Reproduced with Permission of Klaus Wagenbach Verlag, Berlin.

> *Th world / invented to end in a book, out there*
> *Try and reach him, good luck*
> *He is always booked*

» **WORKS CITED**

Barthes, Roland. *A Lover's Discourse: Fragments.* (Trans.) Richard Howard. London: Vintage Books, 2002. np.

Brodsky, Joseph. "Language and Aesthetics." *Nobel Lectures from the Literature Laureates*, 1986-2006. New York and London: The New Press, 2007. 255-267.

Kafka, Franz. *The Zürau Aphorisms of Franz Kafka.* (Trans. w/ introduction and afterword) Michael Hofman & Roberto Calasso. New York: Schocken Books 2004.

Kertész, Imre. *Kaddish for an Unborn Child.* Trans. Tim Wilkinson. New York: Vintage International, 2004.

INSTALLATION/ INSTALLMENT

» BRIAN GRAHAM

I have had a strong resistance to theories of the sentencing machine as a metaphor for 'the writing process' in Kafka, but the way of discussing this and presenting it in the installation certainly differs from views in which 'the world' disappears and writing and torment become the whole issue. In the installation and writing on it, the machine has secrets and Kafka has secrets, and 'reading the world as if the world were himself' is bound to produce torment within. There is a psychoanalytic element that I perhaps do not understand. That the story exposes the secret of the machine, 'the ecstasy of the impersonal'—that I am sure I do understand. In the Benjamin essay cited, "Conversations with Brecht," Brecht also accused Kafka of being a petty-bourgeois with a desire for a leader. Yet in the performance-installation and notes, it is abundantly clear that both the identification with the machine and the identification with the leader are the property of the officer, however instructive the strong point the installation makes of the story's relation to the machines Kafka knew, worked with, and depicted.

Zaslove calls it a Brechtian (in part) staging, and I have long felt that Kafka is more 'Brechtian' than B.B. himself could have known. Perhaps it was the Lao Tzu style of aphorisms that misled Brecht. The notion of 'The Way." It makes me think of the short story "Give it Up". The man has to ask a policeman the way to the station. "You asking me the way?" the policeman says. You know the story. In any case, the policeman knows that it is no use asking a policeman "or any other authority " the way. By definition the authorities have given up long ago. So this petty authority can have his little laugh. In Kafka, all those who have 'given up' and become authorities have a great stake in protecting the system they have given in to. All except this one policeman, who is satisfied to tell the man to 'give it up,' and can turn away "like someone who wants to be alone with his laughter." Follow the leaders, Kafka certainly did; he felt summoned to create in this void (or silence) where authority ruled. The "command": "The machine has a secret memory function that transforms a command into a life of writing...." I won't pretend that I can pry open Zaslove's words (which have his own stamp on them as much as Kafka's his) but Kafka was commanded to give a kind of 'memory' to the (otherwise) "silent" place of the inhuman apparatuses. It is scandalous, what the explorer/reader has to witness; a transgression to be there. And that is what I think the installation is reconstructing; a kind of silent transgressive act within Kafka's imaginative and real world. I thought of another penal colony story after being in the room: *Narrative Of The Life Of Frederick Douglass, An American Slave*. Reading this story, I could confidently say Kafka knew it; he was clearly aware of documents of American slavery. However, unlike Douglass' narrative, which invites the reader to identify with (or at least share the horrors of) the victim(s), in Kafka's story we must suffer the convictions of the perpetrator(s). I know the warning against interpreting the stories as the individual against the world, but seeing 'world' as the place where 'individual' is not permitted to be, is not the same. If Kafka conforms to the world, it is only by imagining and depicting it. 'Literacy' as being in the very place you are not supposed to be. Inside the place where (to paraphrase Zaslove in another context) "the apparatus becomes the subject ... and takes

upon itself an independent existence."[1] By picturing the convictions of those who have already given in to domination, by giving form to their identifications, a space can be preserved that imagines a person who is not dominated. That person can not be found inside the stories. But I tend to read the stories as what the author has overcome, and 'world' not as world *per se*, but dominating world. Many images and scenes from Kafka are engraved into me; sometimes one image appears to jump from one story to the other (in the mind's eye). Robinson's stream of vomit into the elevator shaft, while reading *In the Penal Colony*—or the empty file folder with the name "surveyor" written on it in blue. In this scene of course, the Chairman is the perfect complement of the penal colony Officer; for him the "excellence of the organization" is as inviolable as the perfection of the machine is to the Officer. As Zaslove says, the motifs repeat themselves. Perhaps this is one of the reasons behind the idea for an installation that ranged from the comic to the horrible. Now I'm trying to re-picture it, was the battery connected to the 'gonads' of the Austro-Hungarian officer, the one standing next to the beds, attached to the beds as well? Must have been. When I look into historical texts, and learn about how German Jews were stripped of citizenship "for their protection" and see the beginning of "extra-judicial" killings for the protection of the state by the supreme judge, I find in documents what Kafka already knew in probing them.

Kafka's Father's Fancy Goods Store ("Galanteriewaren"), Reproduced with Permission of Klaus Wagenbach, Verlag, Berlin.

1 "One Way Street: The Production of Literate Culture—The Legacy of Formalism and the Dilemma of Bureaucratic Literacy," in *Quaderno: Filosofia E Scienza Sociali, Nuove Perpettive*, ed. Michele Schiavone, Genoa, 1985, 164.

ZASLOVE AND THE INSURANCE MAN—AN EXPLODED BOOK OF FOOTNOTES

» WILLIE BRISCO

"...'Quotation', then is a term that stands at the intersection of art history and literary analysis, a concept that makes preposterous history specific. Quotation can be understood in a number of distinct ways at the same time, each illuminating an aspect of the art of the present and of the past through their distinct theoretical consequences".

—*Mieke Bal*[1]

"The experience which corresponds to that of Kafka, the private individual, will probably not become accessible to the masses until such time as they are being done away with."

—*Walter Benjamin*[2]

Is it possible to make an installation of one of Kafka's stories? Prior to seeing the installation, *The Insurance Man Kafka in the Penal Colony* at the SFU Gallery, a friend had already described it to me as "a tangled mess". In her words, it was "a bizarre collection of references and paraphernalia, so filled with captions and esoteric detail that would be impossible to collate." Collating aside, knowing something about Kafka and the author of the installation, the description could only make me smile, in addition to making me want to see the show. This may seem like a strange point of departure, but in its own way it gets to the heart of what was difficult in understanding the installation—could Kafka's writing be explicated by its expansion into an installation? My answer here is yes: because the author of the installation, who is known for a specific density of discourse, uses a method that is dialectical and poetic that often concludes without easy synthesis.

Much of the analyses that we are familiar with in these critical times is not only dialectical, but can be poetic as well, thereby raising aesthetic questions, perhaps without providing answers. Specifically, in Jerry Zaslove's classes, literature and photography move through the material, even when they might not be the primary subjects; they help create a complex space where metaphor, history and politics intersect. This installation does that as well; it created a multi-decade history that presented objects by expanding their meanings. The installation transferred much of that phenomenological complexity into the space of the gallery.

The exhibition was like the archipelago of a host of penal colonies on islands that circled the globe. It consisted of a number of "islands" that one could almost visit by walking through the room. There was a slideshow using the archival images of the historic penal colonies and their cage apparatuses—from a book known to Kafka at the time of he wrote the story. There were out-sized quotations on the walls from the story and from Kafka's other writings, almost like islands of texts, and a large bed sculpture—an island in the midst of walls—all of which combined set design with allegory. Vintage studio photos of celebrities from a Prague portrait studio

1 Mieke Bal, "Afterword: Looking Back" in *Looking In: The Art of Viewing. Critical Voices in Art, Theory and Culture*, Edited by Saul Ostrow, Amsterdam, 2001, 272.

2 Walter Benjamin, "Max Brod's Book on Kafka" in *Illuminations*, Translated by Harry Zohn, ed. Hannah Arendt, New York: Harcourt, Brace & World, 146.

contemporary to Kafka graced one wall, and on another wall on the other side of the bed- sculpture were painted portraits that formed another island of contemporary figures who seemed to be spectators to the story; and yet on another wall, anti-war propaganda from WW I illuminated Kafka's helplessness and awareness about WW I's "preposterous history" (Bal) of brutal violence. The exhibition was neither a standard museum display, nor what one might typically think of as an artwork.

The Insurance Man: Kafka in the Penal Colony housed a show inside of a show beside a show and yet another show woven throughout the room. The objects on display were positioned in a contiguous manner. This allowed the collection of objects and the writing that filled the walls to be read both indexically and atmospherically. Like an exploded book of footnotes, the exhibition reanimated Kafka through mapping his proximate reality to the collections in the room. The suggested relationships to the collections situated him in his own time in a number of ways. Through the vast collections, the exhibition sought to create an image not simply of Kafka the man, but to his discursive context that indexed and also projected the relationship of the objects to the reality of the surrounding world. The display thus examined how images and objects that were largely situated in his time could annotate Kafka's insurance career and intimate life. Thus the exhibition, created Kafka as an abstraction that segued towards both the totality and margins of his oeuvre. Kafka the social critic, Kafka the melancholic self-doubter, and a host of other identities were able to exist simultaneously in the room. By holding many perspectives at once, the links between objects and their relevance to Kafka strategically created doubt and uncertainty about Kafka and the background to the creation of the story. Objects functioned transitionally with and without a sense of an obvious metaphorical relationship to the story itself. The installation embedded the viewer into a material history of the story. This might be similar to finding a diary inside of a piece of old furniture. Kafka becomes a free-floating figure of discourse—even of quotation—which could infuse wonder into the everyday objects situated strategically around the gallery. By my referring to the installation as an extension of a teaching style, the parallel style of relating the installation to teaching becomes a strategic placing of Kafka's construction of his stories through the way Kafka and the installation combines different discourses.

Exhibitions we see in galleries these days develop their own ciphers, codes and parsing and often speak to us as literature. There was a cloud of anachronism playing throughout the exhibition, which moved the viewer back and forth through the last two centuries. Touring the exhibition, one was frequently pushed into the past only to be confronted with the present. One found fragments of the world Kafka described in his diaries and letters mounted on the walls and in display cases, only to be led further into the 20th century, where we play out the tragedy of his warnings about the society we have come to live with. For example, in a flat-file display case, a book of drawings done by children, who were confined and then annihilated in either the Térezin or later in the Auschwitz concentration camps, sat there mutely as one of these objects that might be temporally unclear to a spectator. The book of drawings was published as recently as 1993, however its strategic placement in the display case, along with other objects like children's books and travel books from Kafka's own time and place became a "quotation" and a reference to Kafka's interest in children and children's literature and an invitation to remember the murder of Kafka's sisters in the concentration camp.[3]

The discursive space of the exhibition often referred to a history of plunder, torture and colonialism. Viewers were met with a Kafka displayed in

3 Volavkova, Hana, ed. ... *I never saw another butterfly...: Children's Drawings and Poems from Térezin Concentration Camp* 1942-1944, Schocken Books, 1993.

the moment of intersection where self-consciousness towards the violence and chaos of social life begins to crystallize into "quotation" (Bal) that alludes to a language of oppression, incarceration and suffering. Geographically removed from the checks and balances of a watchful culture of law, the island that Kafka created used the abstract geographical location of a distant penal colony to examine the dark potential of unwatched power where power can pursue new and old methods of punishment. Upon this threadbare frontier, the alienating nature of the Colonial European social contract could enter into absurdity with all the gravity and violence that absurdity entailed. We might even see that Kafka the lawyer constructed a judicial case study where the compliant and malleable nature of authority could be made transparent, and the language of Justice and Progress could be shown for the brutality it is often brought to serve as both spectacle and punishment.

The slideshow showing the reality of prison cages, various apparatuses, jungle plantations and portraits of celebrities and groups of prisoners in the penal colonies illustrated a society orchestrated into racialized divisions into the guilty and their righteous keepers. To view the self-imagined reformers masquerading tyranny as progress remains a haunting reminder of the ruthless idiocy and insolent pomp of the human characteristics mimicked in Kafka's stories. In this way, Kafka's story also mimics the ideology of progress in the image of the writing machine. This reminds the viewer of the technological ethos of his times almost forcing the viewer to recognize the enlightened historical progress of the technical means of punishment from garrotes and iron maidens to gas chambers and electric chairs. The story reminds the viewer of the morbid truth of the guillotine festivals and lynching picnics and distills and then mobilizes this social violence into a four-person sitcom. Kafka's "Penal Colony" draws the reader closer into witnessing the grotesque mechanics of this catastrophe. It is from this stand-point that the exhibition can remind us that within Kafka's world of the literary words reify into things reminding us that this catastrophe still haunts us. In this, one is reminded that we, as private individuals, remain ever implicated in the relative nature of the violence of our societies, that, as Walter Benjamin writes, in the quote that is used as an epigraph, "will probably not become accessible to the masses until such time as they are being done away with".

We all know that both the name "Kafka" and the term "Kafkaesque" have become commonplace and have been assimilated into the contemporary vernacular and can "explode" into quotations from those who likely never even read Kafka. We encounter these terms in critical discourse and institutionally both as objects of literature and personal experience. In *The Insurance Man: Kafka and the Penal Colony*, we are offered another view of Kafka, one that mocks the use of the "Kafkaesque" as meaningful anymore, but indexes the many cultural and social images and social variables that bring an author barely published in his own time into view as a minor cultural industry. By situating Kafka into both his and our present, *The Insurance Man Kafka in the Penal Colony* illuminated many of the catastrophic contingencies, which lead to the necessity of "quoting" (Bal) Kafka's writing in ways that detour any attempts to assimilate him into the culture industry. The installation engaged both the everyday banality of "the private individual" (Benjamin) and the dense, dialectical extensions in Kafka that are used in the installation to criticize the culture industry that has already assimilated him and his work. Mieke Baal's comment that I quote as an epigraph might be used to illuminate the Installation, and, to further underscore her point, that by "illuminating an aspect of the art of the present and of the past through their distinct theoretical consequences" the Installation avoids the spectacular and the cliché, and in this way Kafka is reembodied in the room of objects, by being softly bound together by discourse and magic.

Reproduced with Permission of Klaus Wagenbach Verlag, Berlin.

Ema Destinnova, 1896 1896. Opera Singer.
With Permission of Langhans Portrait
Gallery

*Karel Kramar, 1907 1907; politician, lawyer,
economist.* Reproduced with permission
Langhans Portrait Gallery.

CONTRIBUTORS

Ian Angus is currently Professor of Humanities at Simon Fraser University. His most recent books are *Identity and Justice* (University of Toronto Press, 2008) and *Love the Questions: University Education and Enlightenment* (Arbeiter Ring Press, 2009).

Lee Bacchus is an SFU graduate (English) and for 20 years wrote for The Vancouver Sun and Province as feature writer, movie and television critic, and pop culture columnist. Currently he is a freelance writer and photographer who also teaches photography at Focal Point School in Vancouver.

A member of the board of the Kootenay School of Writing, managing editor of the literary magazine *West Coast LINE*, **Michael Barnholden** is the author of several books of poetry and non-fiction, most recently *Circumstances Alter Photographs* (Talon Books, 2009).

Michael Bourke teaches literature and philosophy courses in the liberal studies programme at the British Columbia Institute of Technology.

Willie Brisco is an archivist/activist interested in the analytics of methodology and the historiography of the present. He has contributed to *Fillip*, and *ArtForum*.UNITEDNATIONSPLAZA Berlin, E-Flux Pawnshop, Villa Villa Nola Records, Palimpsest Magazine, Galerie Accidentale and others. He is the curatorial director of the Galerie Werner Whitman.

Rob Brownie writes and teaches in Vancouver. He has written on the themes of art and architecture for *West Coast Line*, Artspeak Gallery, and *Vancouver Matters* (Blue Imprint, 2008). In 2009 he travelled to Berlin with a copy of Kafka's "The Castle"

Kathi Diamant is adjunct professor at San Diego State University, where she leads the Kafka Project, the official international search to recover the missing writings of Franz Kafka. Her book, *Kafka's Last Love: The Mystery of Dora Diamant,* received critical acclaim and has been published in six languages.

Brian Graham, by way of a career, has long toiled in classrooms of private schools without a grain of esteem for private education. He considers Kafka, among a handful of others, one of those he is most indebted to for their integrity and penetrating understanding of the modern condition.

Mark Jaskela was born in Vancouver in 1960. He earned a bachelor's degree in visual art and a master's degree in liberal arts and social sciences at Simon Fraser University. He is a writer, artist and leads Christian faith-based support groups for people with mood disorders. Presently, he is completing a book of essays on popular culture.

Bill Jeffries has been Director/Curator at the Simon Fraser University Gallery since 2005. He was previously Director/Curator at Presentation House Gallery in North Vancouver and the Contemporary Art Gallery in Vancouver.

Tom McGauley, Kootenay boy, worker, singer of the chrysoprase confluence, India-headed, named Ayanar, in Tamil, after the invisible night watchman of the village of strong words and passionate curiosity.

Tom Morris has worked as a campaigner for Amnesty International and taught literature and cultural criticism at universities in Canada and Zambia. Current interests include wayfinding (travel writing, personal memory, history of mapping, archaeological digs) as critical metaphor, and the enclosing/administering of lived places.

ryan andrew murphy became a dad in 2009. He has published poetry and essays exploring language and politics; he recently edited an issue of *West Coast Line* on art and anti-colonialism. He is currently a graduate student in Education at UBC, developing an immanent critique of contemporary anarchism.

carl peters wrote his MA thesis on bpNichol and the Kabbalah and his doctoral thesis on Nichol and the practice of the sacred. His critical study of bill bissett is due out from Talonbooks in the spring of 2011. Dr. Peters teaches poetics and avant-garde art at the University of the Fraser Valley.

Kaia Scott holds an MA in cultural theory from SFU. Her writing works at coaxing art and ideas from one constellation into another. She works in writing, editing, teaching, and with the curious entity known as "the public".

An emigrant from a quasi-Kafkaesque world, **Peyman Vahabzadeh** has been living on the West Coast of Canada for 21 years. He is the author of eight books, and his poems, short stories, essays, papers, memoirs, and interviews have appeared in English, Persian, German, and Kurdish.

Jerry Zaslove defines his work by the medium he works in. Teaching and writing has been in the arts and critical theory and social radicalism. Recent writing includes essays on Kafka, Siegfried Kracauer, Herbert Read, Wayne Burns and the novel, Walter Benjamin's anarcho-modernism and the city, photography and memory, as well as essays against the university as it has come to be.